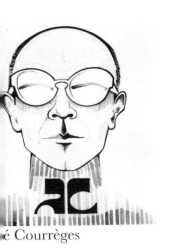
é Courrèges

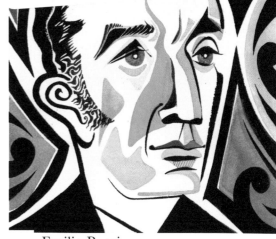
Pierre Cardin

Emilio Pucci

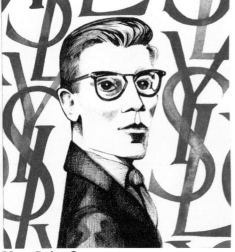
Yves Saint Laurent

Yeohlee Teng

Rudi Gernreich

l Lagerfeld

Giorgio Armani

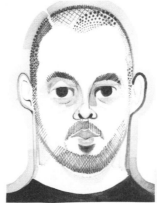
Alexander McQueen

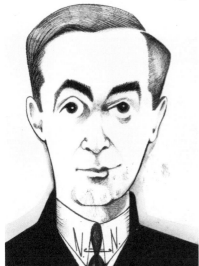
Norman Norell

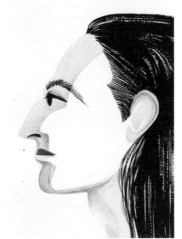
Rick Owens

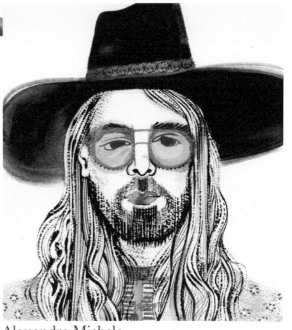
Alessandro Michele

Norma Kamali

Tom Ford

Isabel Toledo

Ralph Rucci

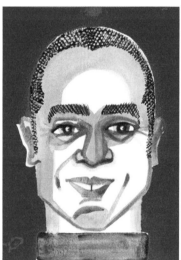

Jeffrey Banks

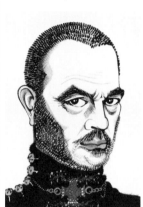

Christian Lacroix

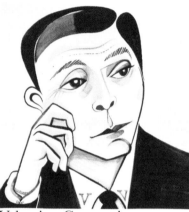

Valentino Garavani

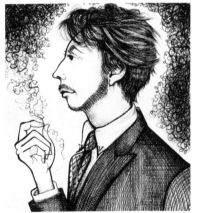

Pierpaolo Piccioli

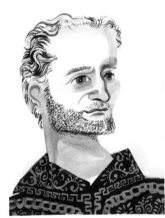

Gianni Versace

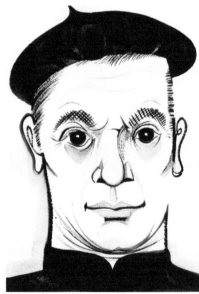

Azzedine Alaïa

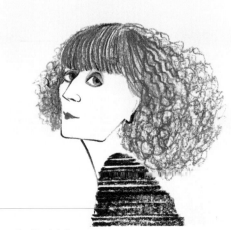

Sonia Rykiel

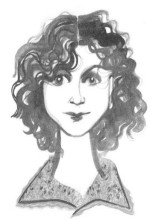

Thea Porter

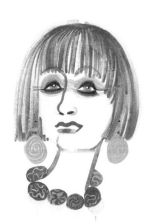

Zandra Rhodes

Be-Spoke

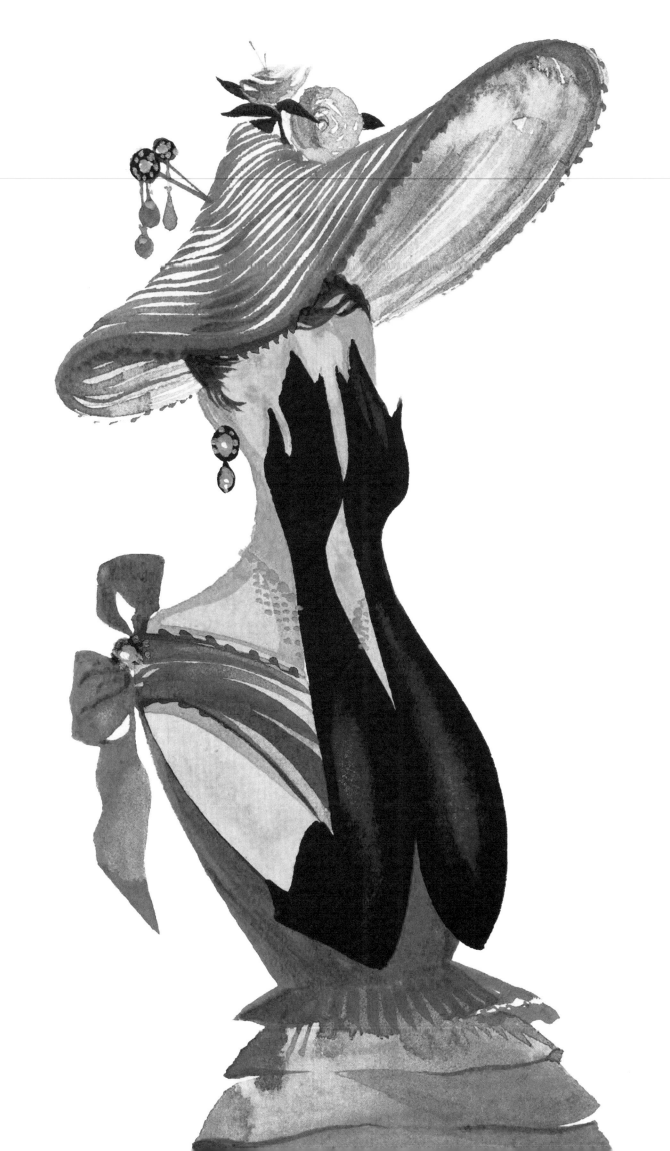

Be-Spoke

Revelations from the World's Most Important Fashion Designers

Marylou Luther

Illustrated by
Ruben Toledo

RIZZOLI
NEW YORK

New York · Paris · London · Milan

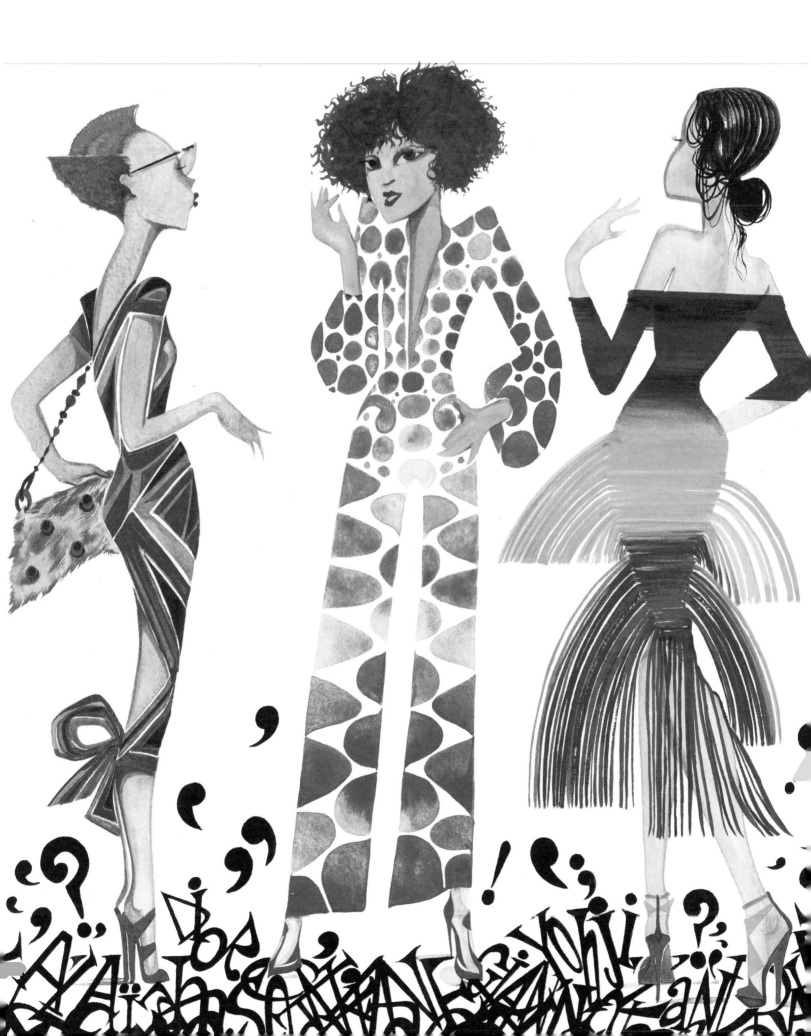

TABLE OF CONTENTS

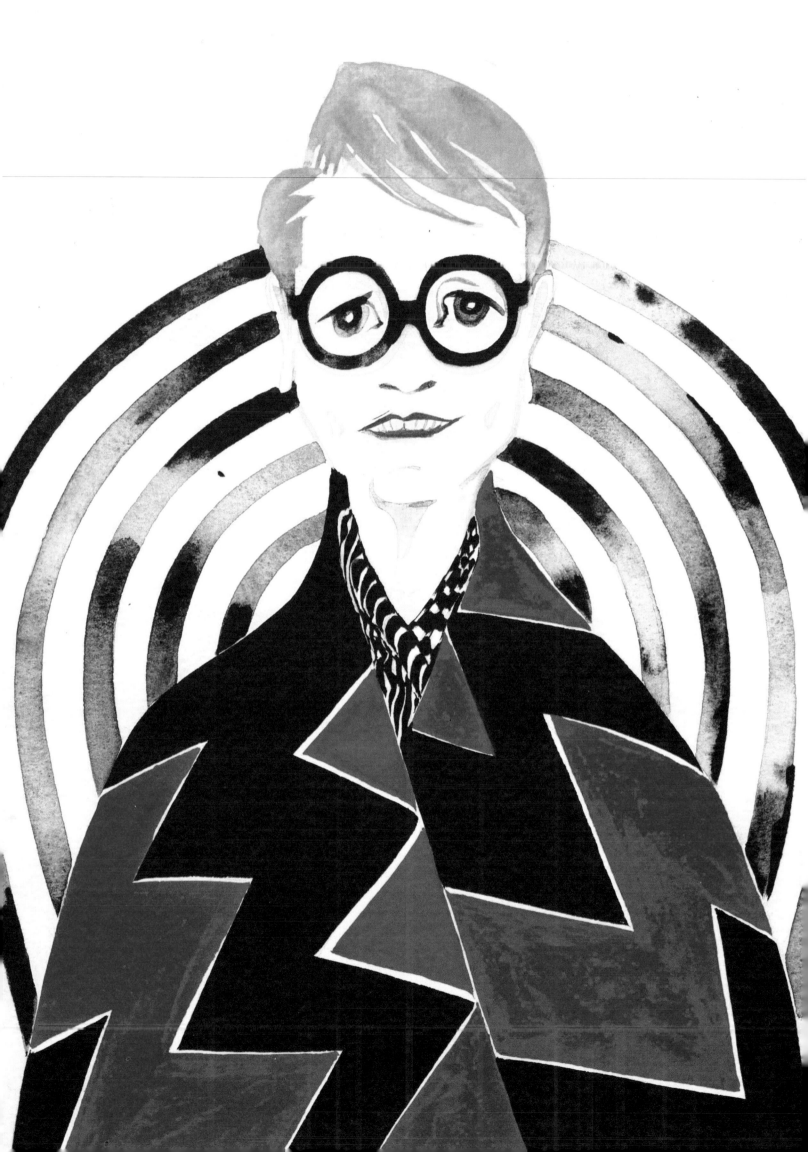

PREFACE

Ever since Eve put on the fig leaf and Japanese courtiers held court in their kimonos, the past has been present in fashion. There was Cleopatra in her nemes, Marie Antoinette in her panniers, Queen Victoria in her bustles, Malayan women in their sarongs, cross-dressers like Marlene Dietrich in their tuxedos, and Moroccans in their abayas.

Through the years, generations have seen those clothes and clothes of many, many others. But they have rarely heard from the men and women who designed them.

Until now.

This book, *Be-Spoke,* is an illustrated collection of quotes dating from Coco Chanel, born in 1883, to Kerby Jean-Raymond of Pyer Moss, born in 1986, and everyone in between.

These quotes are from my interviews as a fashion journalist for the *Des Moines Register,* the *Chicago Tribune, McCall's Fashionews,* the *Los Angeles Times,* the Los Angeles Times Syndicate, the International Fashion Syndicate and Fashion Group International, plus designers' program notes from their fashion shows and, in some instances, from personal exchanges.

What makes this virtual *word-robe* so special is that the quotes are illustrated by artist extraordinaire Ruben Toledo, whose fantastic artworks bring to life the quotes they illustrate. To get right to it, *Be-Spoke* is a coffee table book with cream and sugar.

Marylou Luther

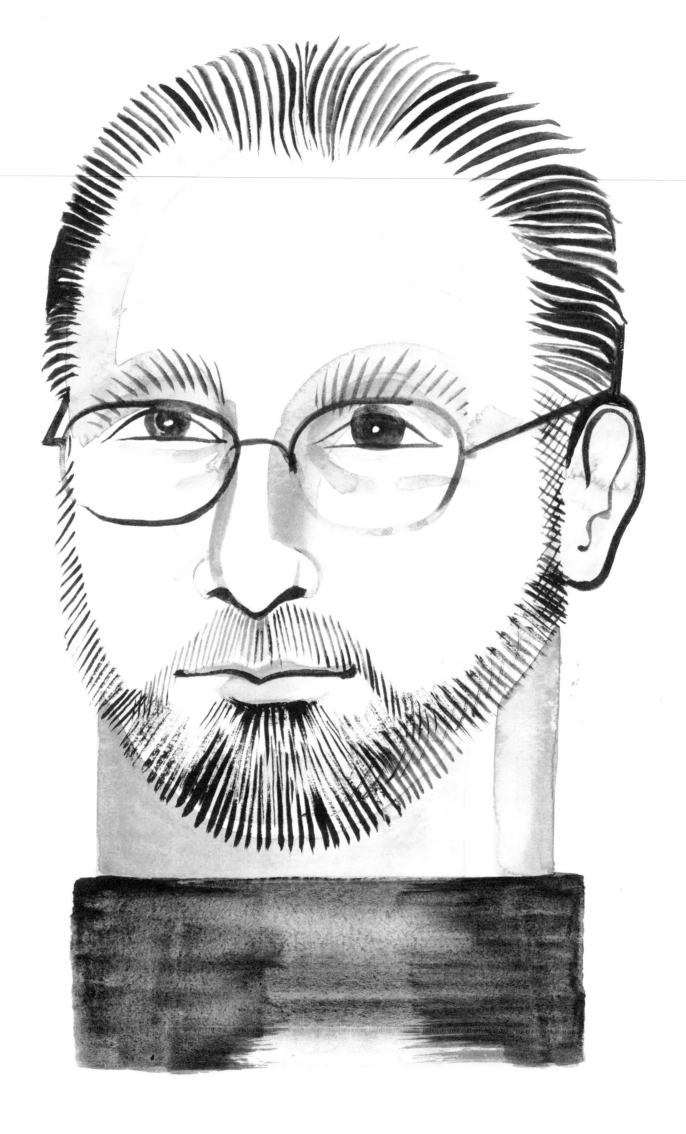

FOREWORD

My relationship with Marylou goes back over sixty years. In fact, she was the first journalist who documented my career in fashion. Even back then she was searching for new talent, looking for answers, and building relationships and trust between designers and the press. This book is the culmination of that trust.

After all, as she says, she comes from the heartland of America, smack dab in the middle of the country: Cambridge, Nebraska, population 1,200 when she is there. She is a cornhusker at heart, who has been able to gracefully infiltrate East Coast /West Coast sophistication with her own sense of style.

The silhouette I see walking the neighborhood we share in Manhattan, dressed in her signature black, would look comfortable in any of the world's fashion capitals. The longevity of her career and its connection to the past has been possible because she remains a force in the present. This book attests to that.

For decades her Fashion Group presentations of the International Collections were a must-see for anyone in the business. I can think of no one in our industry who was able to present such a clear picture of trends, and their effect on the zeitgeist of fashion, than Marylou when she conducted the panel discussions after those presentations.

A woman of words, her use of onomatopoeia never became kitsch. Her respect for the process of design was always obvious in her choice of words.

I believe the maturation of our industry occurred only when the voice of the designer was heard, and in this book, Marylou illuminates those voices. And Ruben Toledo's incisive, lyrical sketches add music to her libretto.

Stan Herman

Gabrielle "Coco" Chanel

(1883–1971) French. Designer, businesswoman, founder of Chanel.

"Fashion fades. Only style remains the same. Only those with no memory insist on their originality. Yves Saint Laurent has excellent taste. The more he copies me, the better taste he displays."

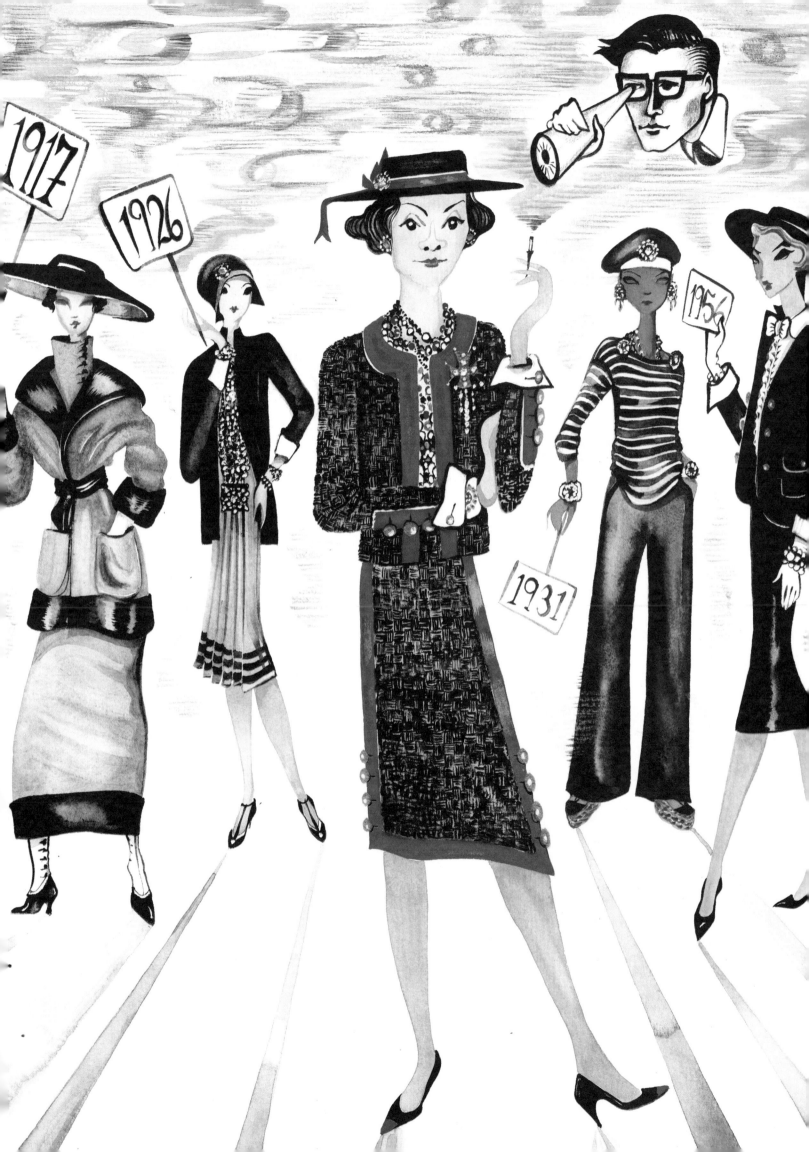

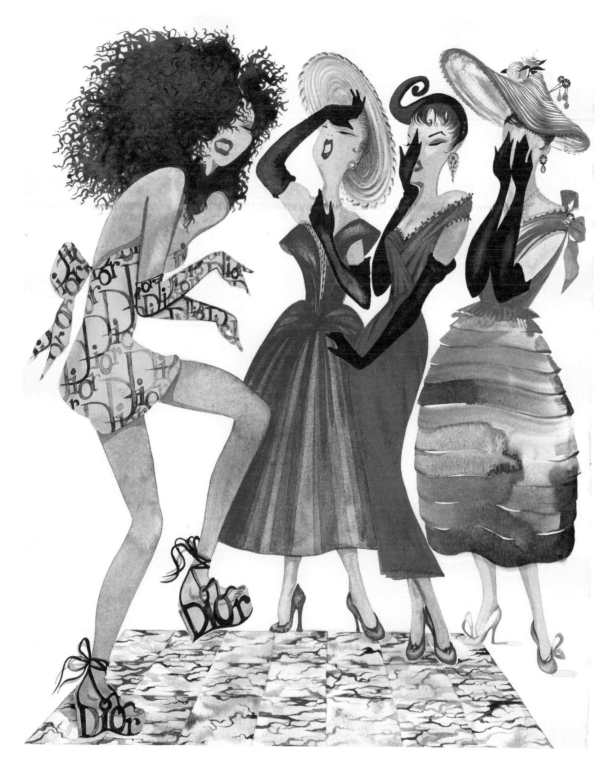

Christian Dior

(1905–1957) French. Designer, founder of eponymous brand.

"When *I* came to Chicago for the tenth anniversary of my 1947 New Look collection, you asked me if it were true that I said women's knees were unsightly. And I answered, 'I think you've asked me a naughty question.' And the answer is: Yes, I said that."

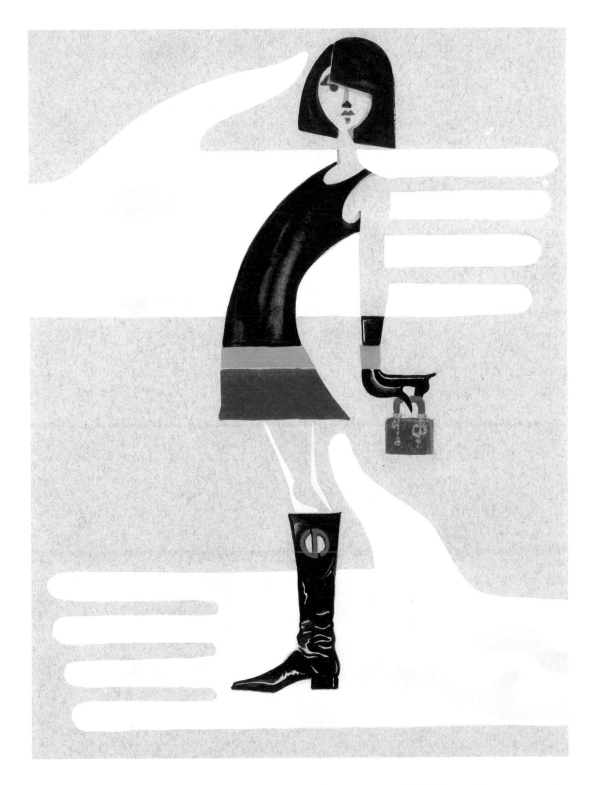

Maria Grazia Chiuri

(1964–) Italian. Creative director of Christian Dior.

"The handmade, analog approach is the antidote to the digital deprivation of individual character in order to maintain authentic individuality."

André Courrèges

(1923–2016) French. Designer, engineer, founder of Courrèges.

"Major trends which impact society for seven years or more always begin after a major calamity or scientific breakthrough. Fashion flowered in the 1930s following the stock market crash; Christian Dior's New Look of 1947 emerged after World War II; the youthquake of the 1960s followed the introduction of the pill; the pants revolution followed man's landing on the moon."

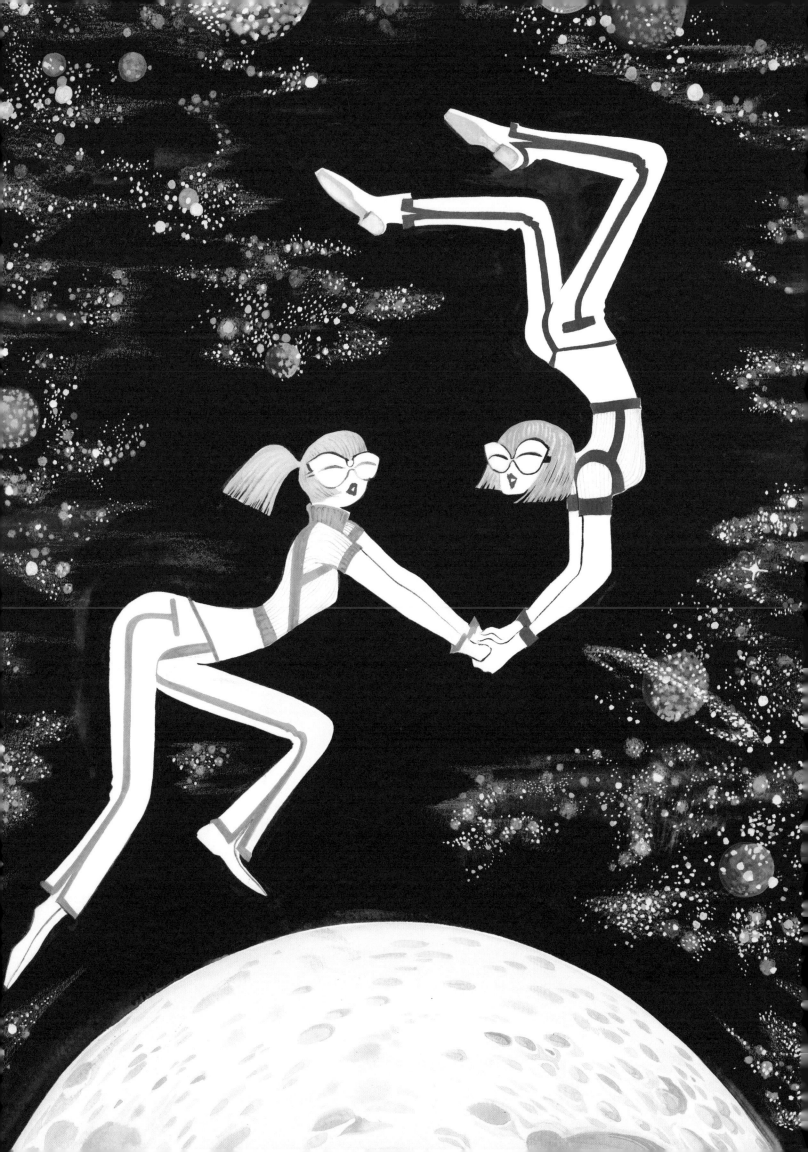

Pierre Cardin

(1922–2020) Italian-French. Designer, founder of eponymous brand.

"The immensity of the universe and microscopy of the cell, computers, and geometry. These are the sources of my inspiration. The garments I prefer are those I create for tomorrow's world."

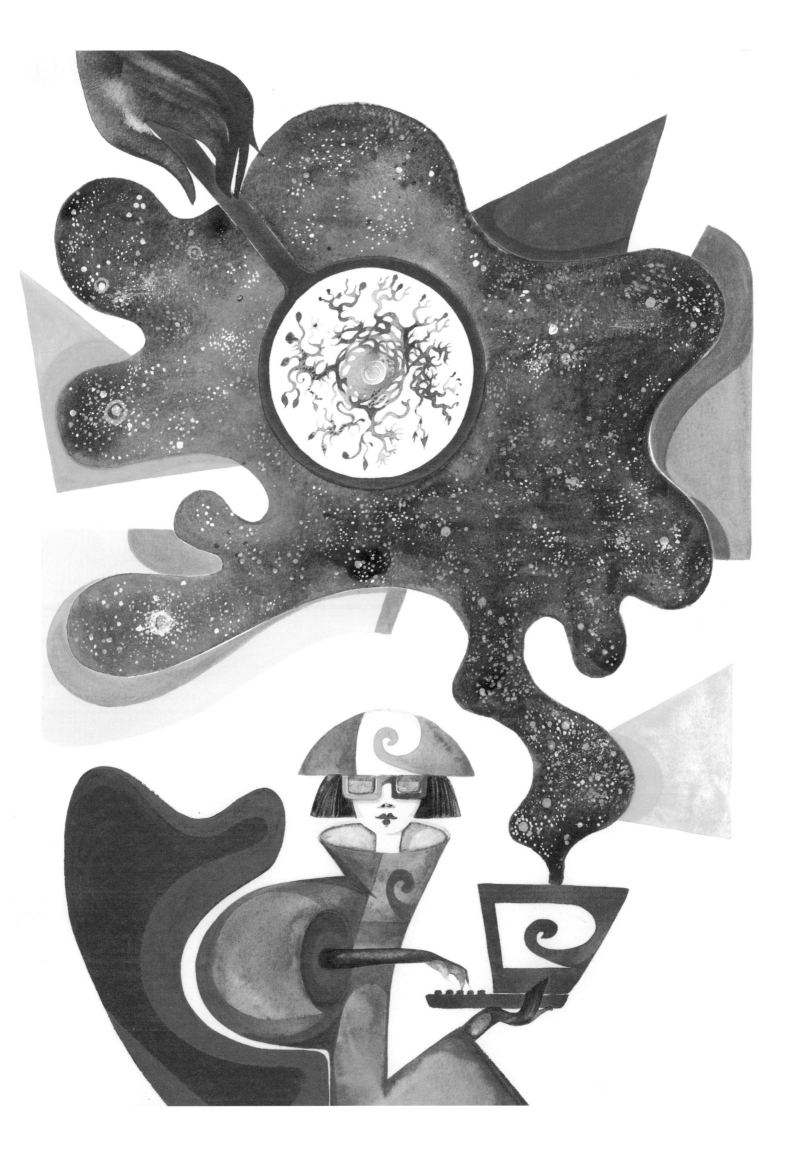

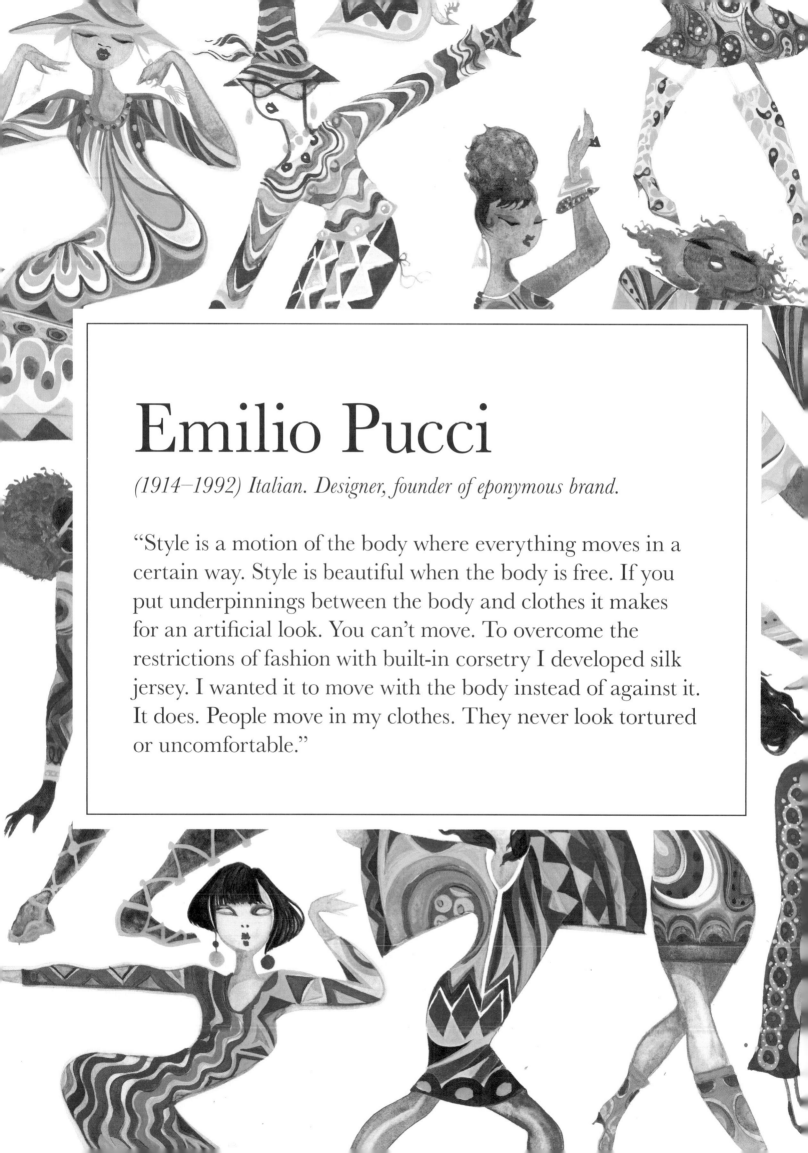

Emilio Pucci

(1914–1992) Italian. Designer, founder of eponymous brand.

"Style is a motion of the body where everything moves in a certain way. Style is beautiful when the body is free. If you put underpinnings between the body and clothes it makes for an artificial look. You can't move. To overcome the restrictions of fashion with built-in corsetry I developed silk jersey. I wanted it to move with the body instead of against it. It does. People move in my clothes. They never look tortured or uncomfortable."

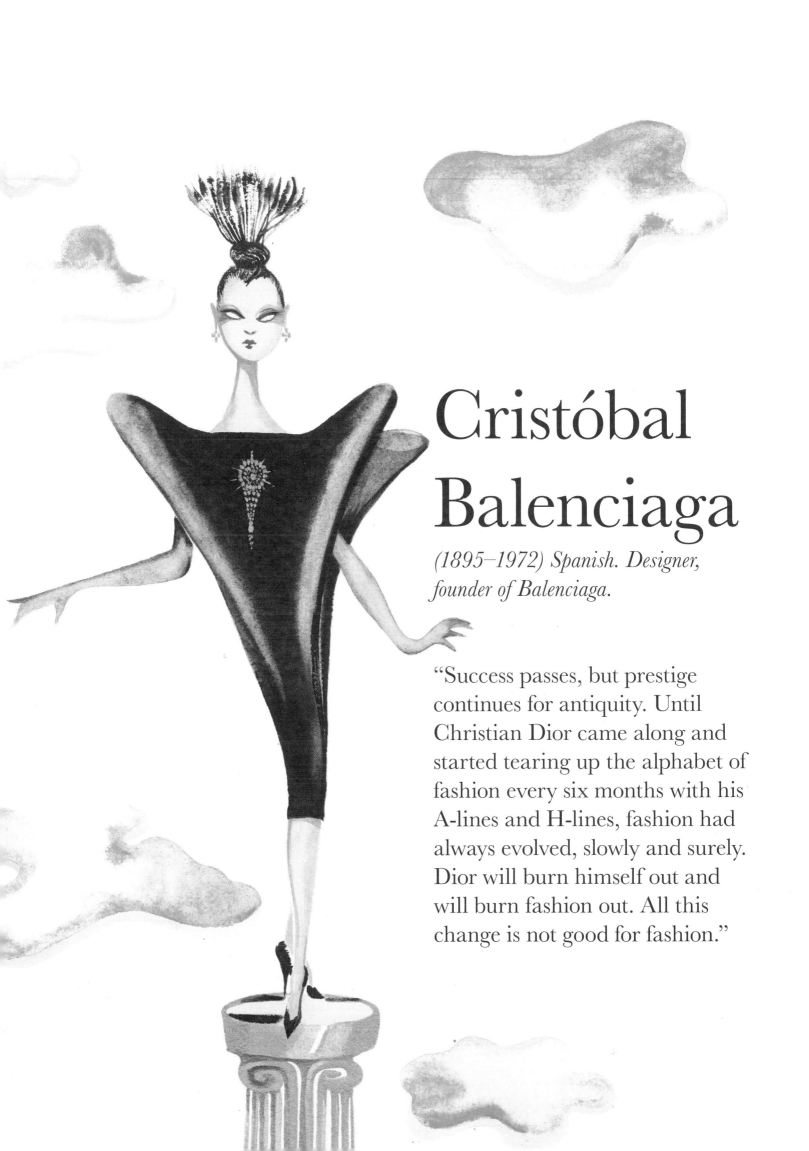

Cristóbal Balenciaga

(1895–1972) Spanish. Designer, founder of Balenciaga.

"Success passes, but prestige continues for antiquity. Until Christian Dior came along and started tearing up the alphabet of fashion every six months with his A-lines and H-lines, fashion had always evolved, slowly and surely. Dior will burn himself out and will burn fashion out. All this change is not good for fashion."

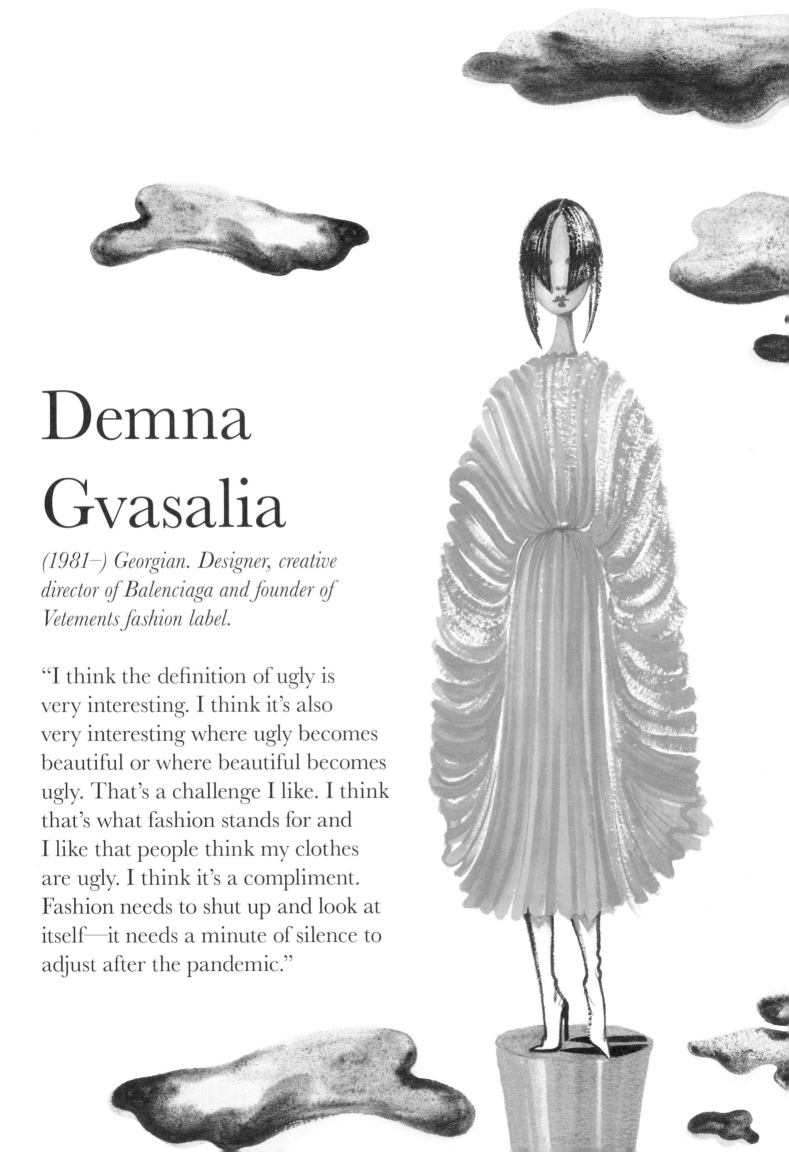

Demna Gvasalia

*(1981–) Georgian. Designer, creative
director of Balenciaga and founder of
Vetements fashion label.*

"I think the definition of ugly is
very interesting. I think it's also
very interesting where ugly becomes
beautiful or where beautiful becomes
ugly. That's a challenge I like. I think
that's what fashion stands for and
I like that people think my clothes
are ugly. I think it's a compliment.
Fashion needs to shut up and look at
itself—it needs a minute of silence to
adjust after the pandemic."

Hubert de Givenchy

(1927–2018) French. Designer, founder of Givenchy.

"My relationship with Audrey Hepburn began as a case of mistaken identity. I thought I was about to be introduced to Katharine Hepburn so my first words to Audrey were 'But you are not Katharine Hepburn.' She responded with 'No, I'm very sorry. I am Miss Audrey Hepburn.' You could say it was an accidental love story that has lasted for years."

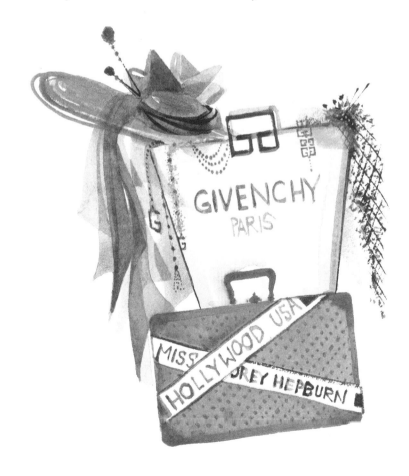

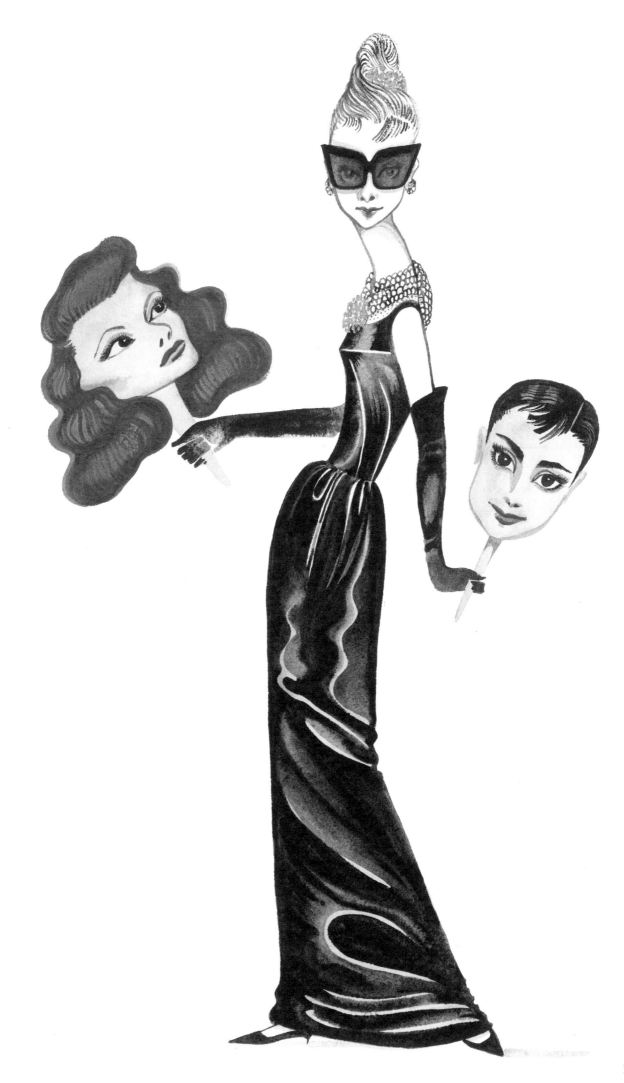

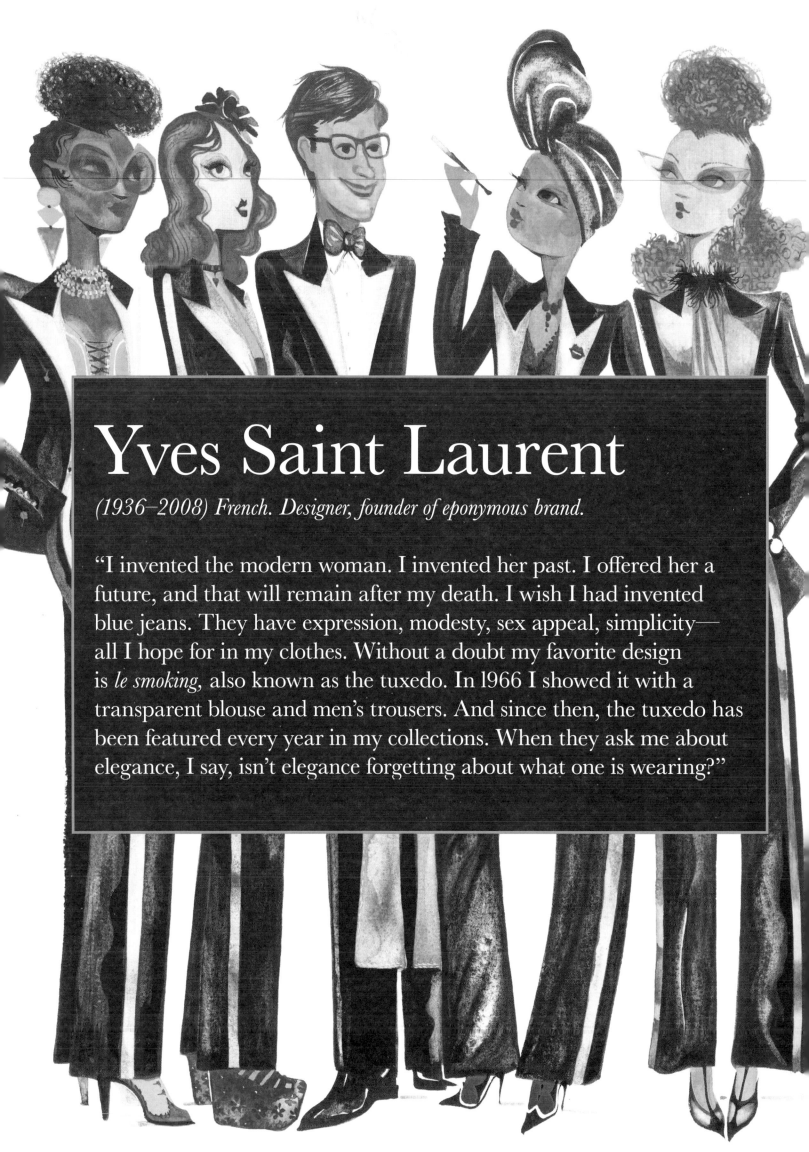

Yves Saint Laurent

(1936–2008) French. Designer, founder of eponymous brand.

"I invented the modern woman. I invented her past. I offered her a future, and that will remain after my death. I wish I had invented blue jeans. They have expression, modesty, sex appeal, simplicity— all I hope for in my clothes. Without a doubt my favorite design is *le smoking,* also known as the tuxedo. In l966 I showed it with a transparent blouse and men's trousers. And since then, the tuxedo has been featured every year in my collections. When they ask me about elegance, I say, isn't elegance forgetting about what one is wearing?"

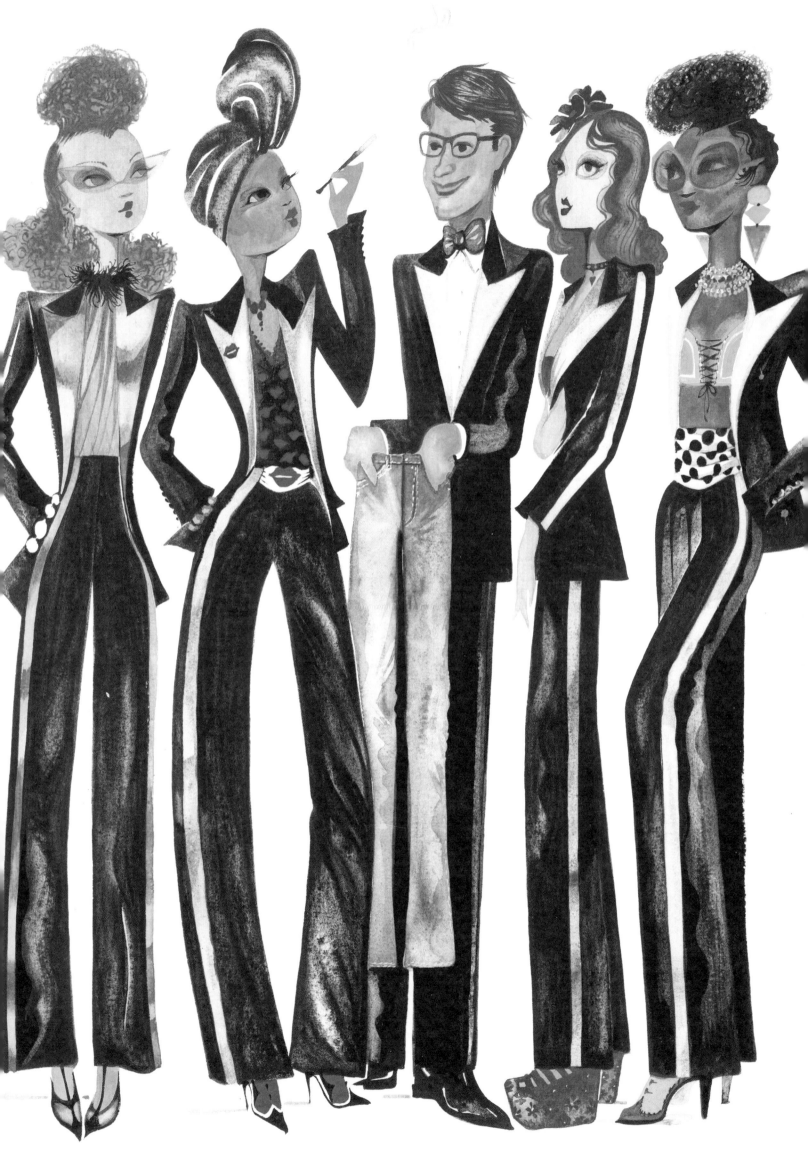

Yeohlee Teng

(1951–) Malaysian. Designer, founder of Yeohlee.

"Clothes have magic. Their geometry forms shapes that can lend the wearer power."

Rudi Gernreich

*(1922–1985) Austrian-born American. Designer, dancer,
founding member of the Mattachine Society.*

"Prior to the 1960s, clothes were clothes. Nothing else. Then, when
they started coming from the streets, I realized you could say things
with clothes. Design was not enough. Probably because of the impact
of my topless bathing suit of 1964 I became much more interested in
clothes as sociological statements. I feel it's important to say something
that is not confined to its medium."

Geoffrey Beene

(1924–2004) American. Designer, founder of eponymous fashion label.

"I do not wish to be clever or on the cutting edge. I have a compulsion to contest them. They manipulate. This is 'in,' This is 'out.' It's ridiculous. Also ridiculous is John Fairchild's long-standing Beene ban. That's why I call him John Unfairchild."

Donna Karan

(1948–) American. Designer, founder of Donna Karan, DKNY, and Urban Zen.

"When I first came up with my buy-now/wear-now idea it was because I felt the industry was not talking to the consumer. She wanted—and still wants—timeless, seasonless clothes. And she wants them when she wants them. I tell her 'buy in season what you love and it will last forever.' And then I list my seven easy pieces to make it work: 1. The bodysuit. 2. The wrap-and-tie skirt. 3. The camel blazer (my father was a custom tailor). 4. The cashmere sweater. 5. The suede jacket. 6. The camel coat. 7. The sequined wrap-and-tie skirt for evening. And now: if all I need in life is one thing, it's a scarf."

Betsey Johnson

(1942–) American. Designer for Alley Cat and eponymous brand.

"Once at a Donna Karan-focused CFDA event dealing with the problem of clothes that don't match the weather when they are delivered—spring clothes when it's freezing; winter clothes when it's warm—I said that I was able to do buy-now/wear-now clothes by using mid-weight fabrics—except for coats and swimwear. Most were made of cotton and Lycra jersey. Stretchy, sensible, sexy, seasonless, weather-right, timeless clothes."

Karl Lagerfeld

(1933–2019) German. Designer, creative director for Chanel, Fendi, and eponymous fashion label.

"The slow, almost invisible evolution of a concept some see as unchanging and immutable, but which in reality changes with fashion, but more slowly. Everyone has his or her 'classics,' but if they don't fit with today's world they die of indifference. I want to be impossible, even for people I love deeply. I don't want to be real in other people's lives. I want to be an apparition."

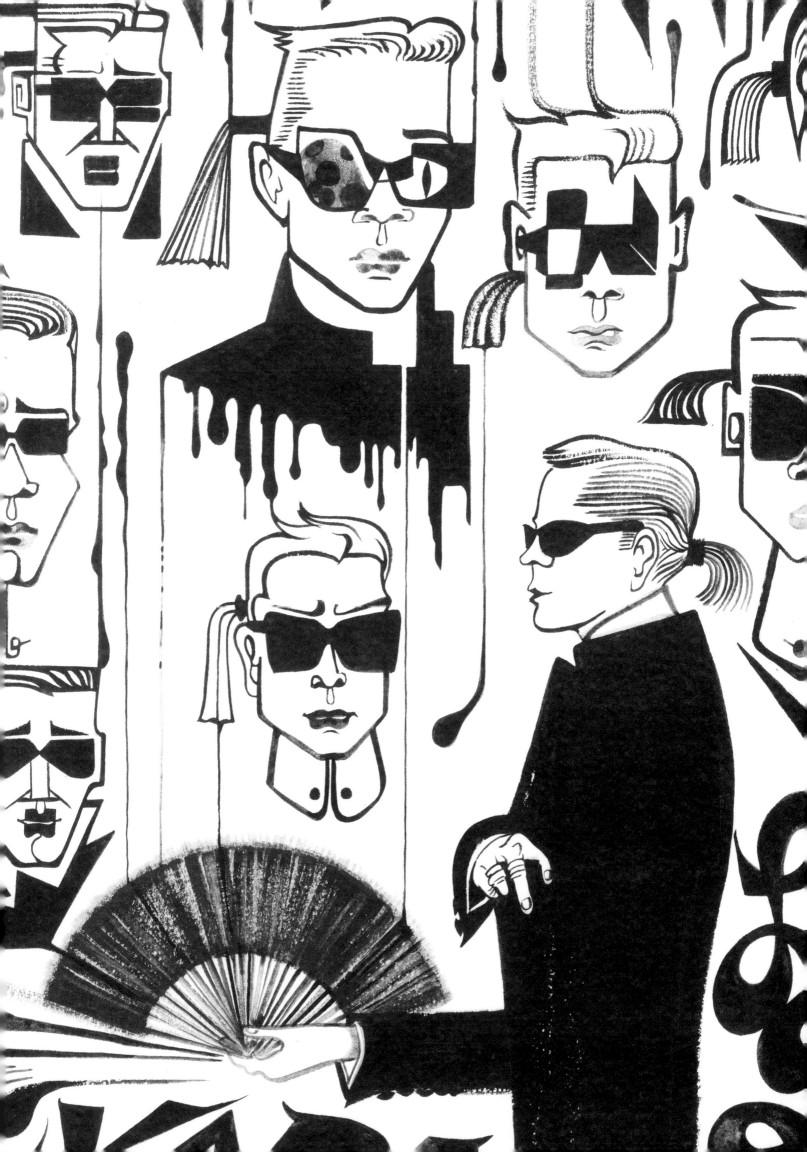

Giorgio Armani

(1934–) Italian. Designer, founder of Armani.

"I don't believe elegance can be revisited. The reason: it's not about the clothes. It's about a way of being. The allure of Hollywood—the clothes, the way the stars were photographed with their picture-perfect makeup. Cinema in the 1980s, when I first got involved with Hollywood by dressing Richard Gere in *American Gigolo,* was about a dream. Now it's about reality."

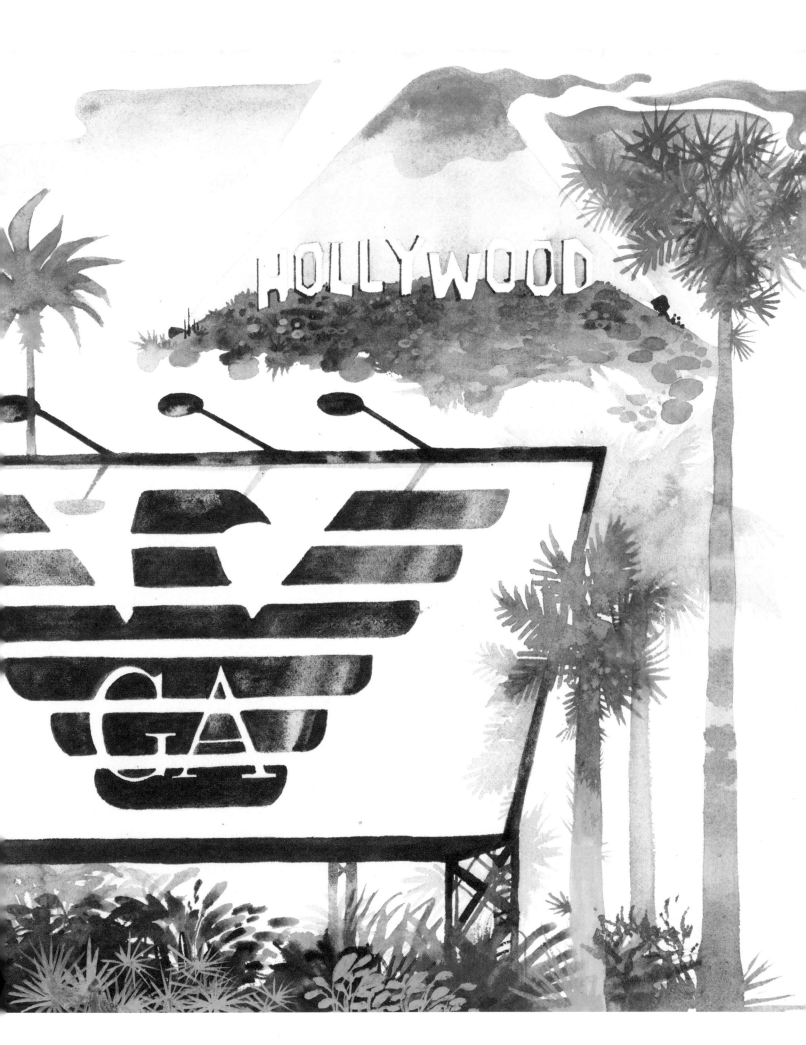

Alexander McQueen

(1969–2010) British. Designer for Givenchy and eponymous fashion label.

"You can never take anything for granted in fashion. The only way to keep going in the right direction is to be constantly apprehensive. Fear is my best friend."

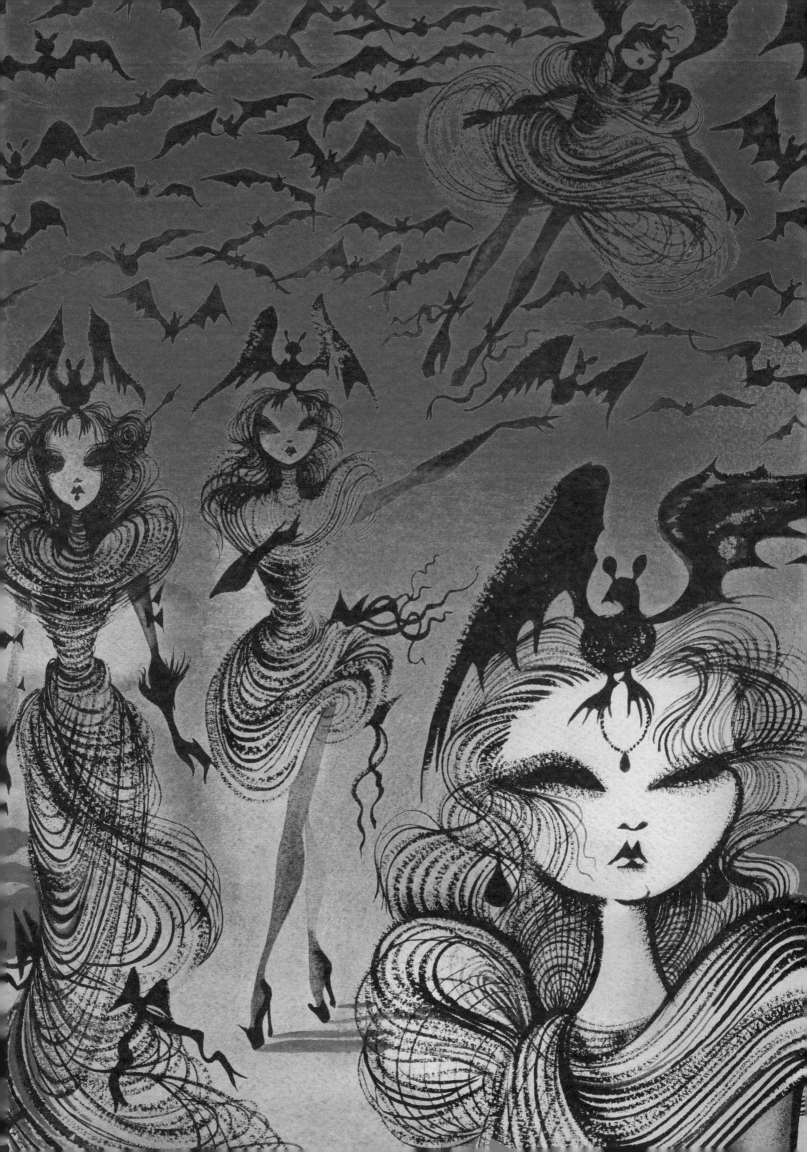

John Galliano

(1960–) British. Creative director of Maison Margiela. Designer for Givenchy, Dior, and eponymous fashion label.

"Women are women, and hurray for that. The problem is with men. I know I shouldn't say this, but they've shrouded and hidden women to hide their own incompetence."

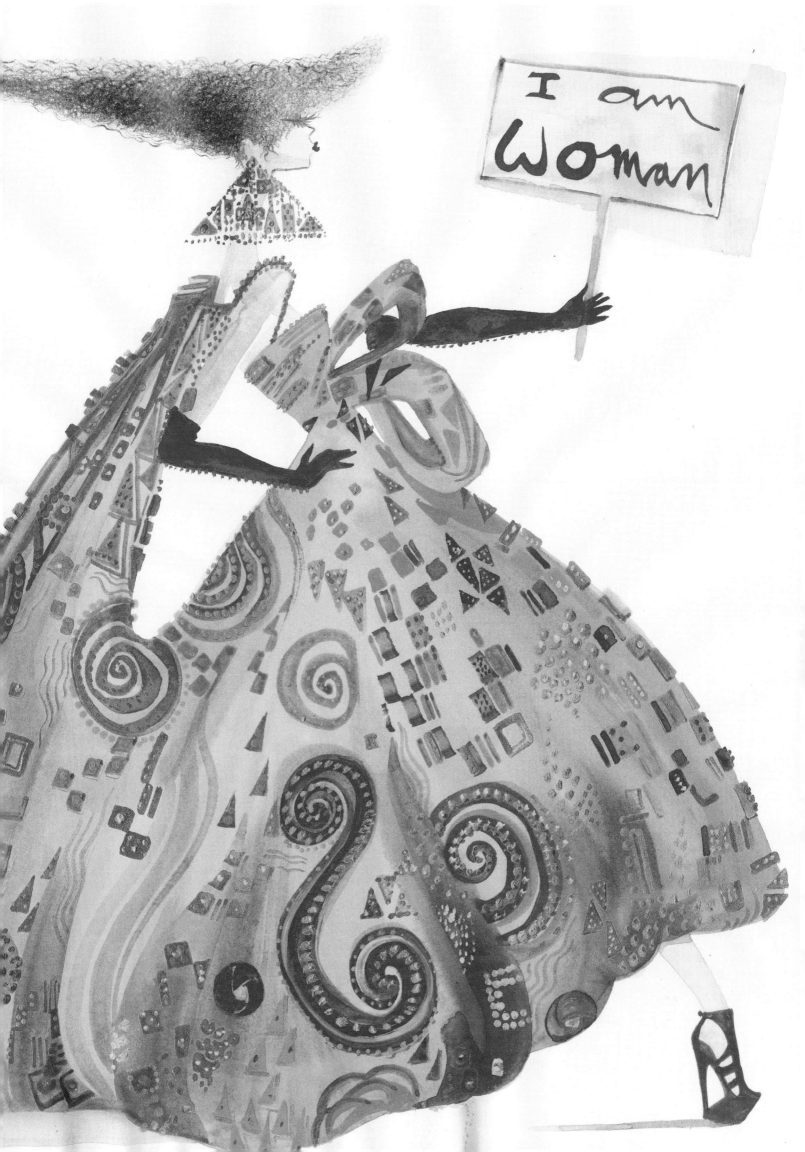

Miuccia Prada

(1949–) Italian. Designer, head of Prada, founder of Miu Miu.

"For so long we have been living in the past. Maybe we are finally reaching the changeover."

Raf Simons

(1968–) Belgian. Designer, founder of eponymous sportswear label, co-creative director with Miuccia Prada at Prada, creative director emeritus at Jil Sander, Dior, and Calvin Klein.

"I'd like to see fashion slow down a bit. What freaks me out about fashion today is the speed—the speed of consuming, the speed of ideas. When fashion moves so fast it takes away something, something I have always loved, which is the idea that fashion should be slightly elusive. Hard to grasp. Hard to find."

Norman Norell

(1900–1972) American. Designer, founder of Norell.

"I was in Chicago for a personal appearance at Marshall Field's. At the dinner party following my show, a man at my table came up to me. He wanted to know if I would ask the woman seated next to him to marry him. If I would tell her to say yes, he persisted, he knew she would say yes. I did. She did. And they got married a few weeks later. I know you know this story, Marylou, because you were that woman."

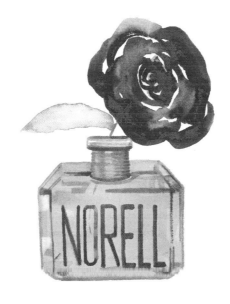

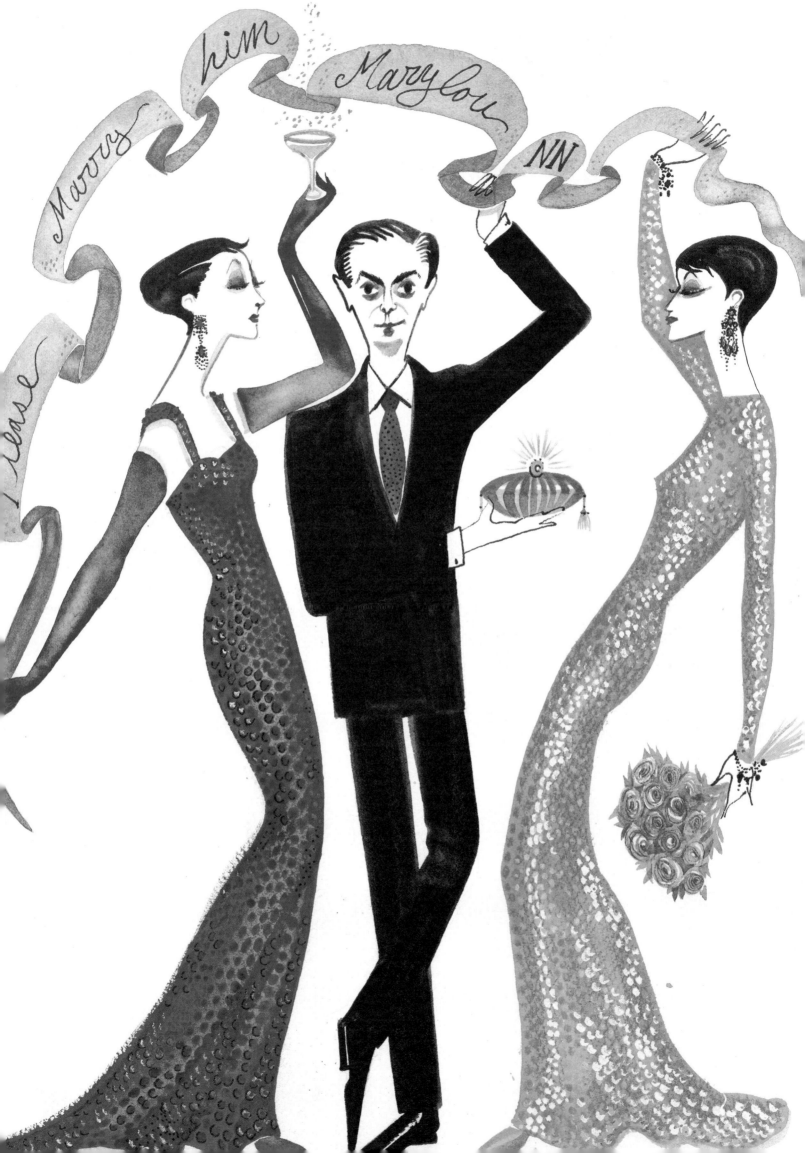

Rick Owens

(1961–) American. Designer, founder of eponymous fashion label.

"I just think about how to live with all this negativity. The only answer I see is that in coping with discomfort or suffering, we now have an unprecedented amount of luxury: a level of knowledge we did not have before. And knowledge is power. The world has never known such luxury. If this world is gonna go down, I'm going down in heels and shoulder pads, not a cozy sweatsuit."

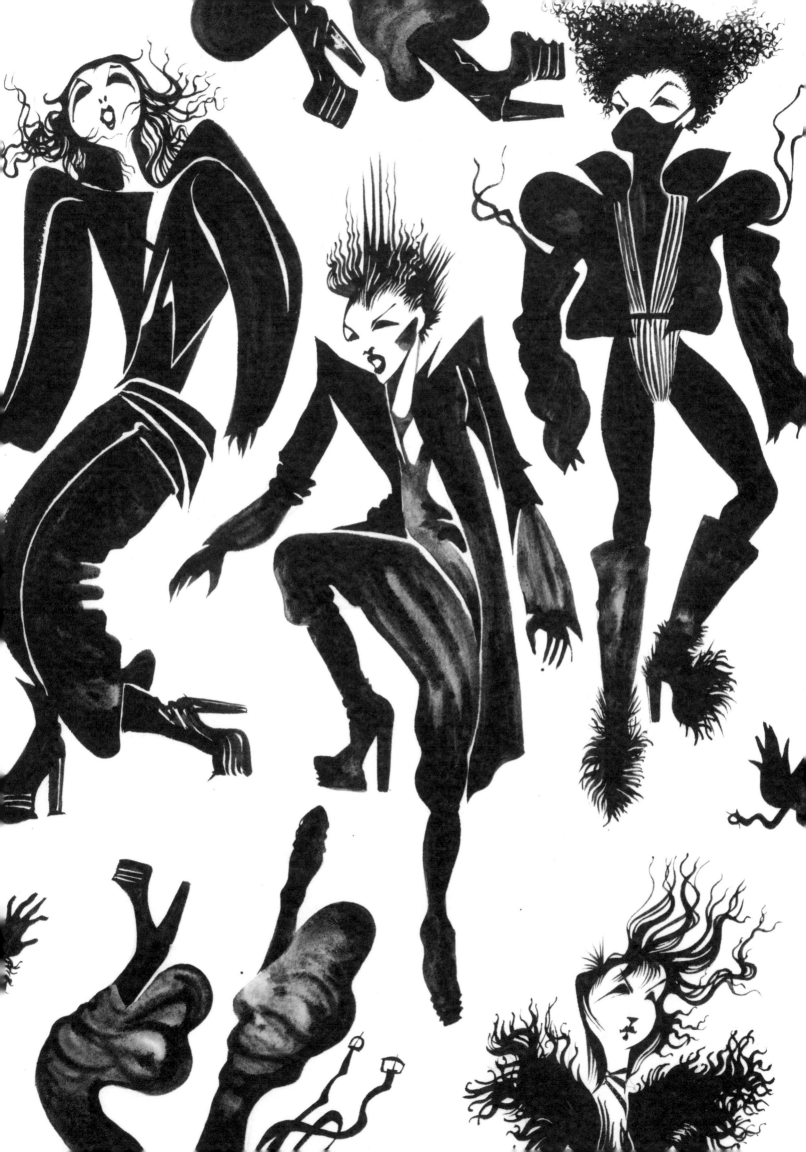

Alessandro Michele

(1972–) Italian. Designer, creative director for Gucci.

"Fashion should be genderless."

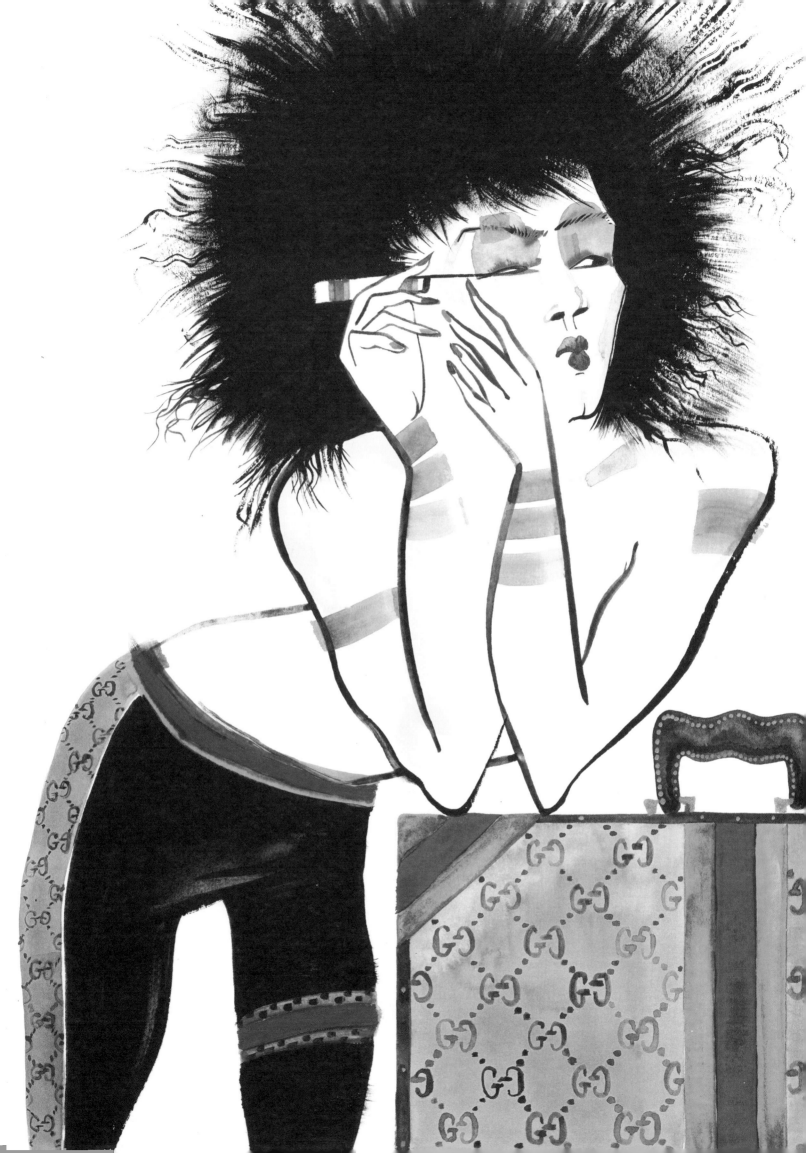

Norma Kamali

(1945–) American. Designer, founder of eponymous fashion label.

"I guess that in the end it really doesn't matter who did what first, if you really love doing it. But it's nice every once in a while to get recognition for it. It would also be nice if we could make the shopping experience fun again by eliminating the men's department and the women's department and label clothes with sizes for all. Gender fluidity is not a fashion trend; it's a movement."

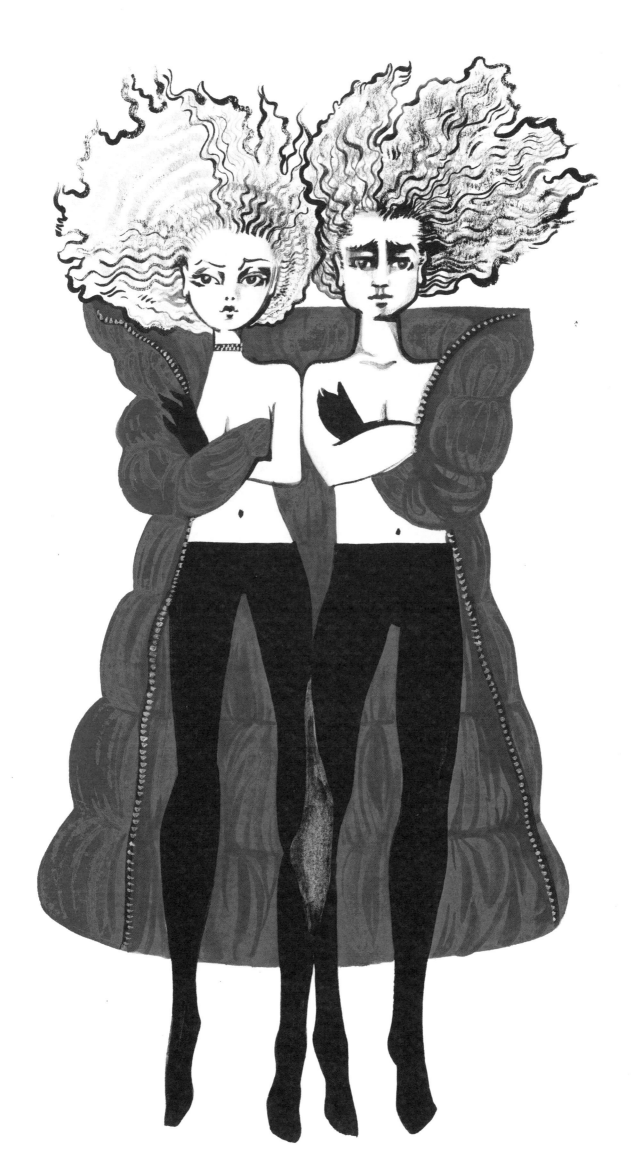

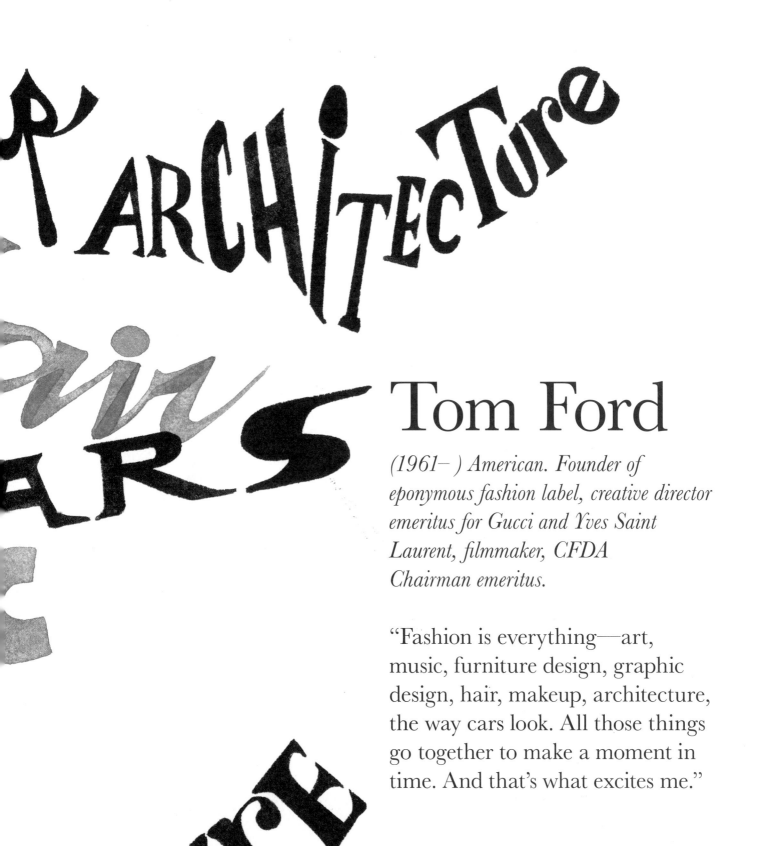

ARCHITECTURE

Tom Ford

(1961–) American. Founder of eponymous fashion label, creative director emeritus for Gucci and Yves Saint Laurent, filmmaker, CFDA Chairman emeritus.

"Fashion is everything—art, music, furniture design, graphic design, hair, makeup, architecture, the way cars look. All those things go together to make a moment in time. And that's what excites me."

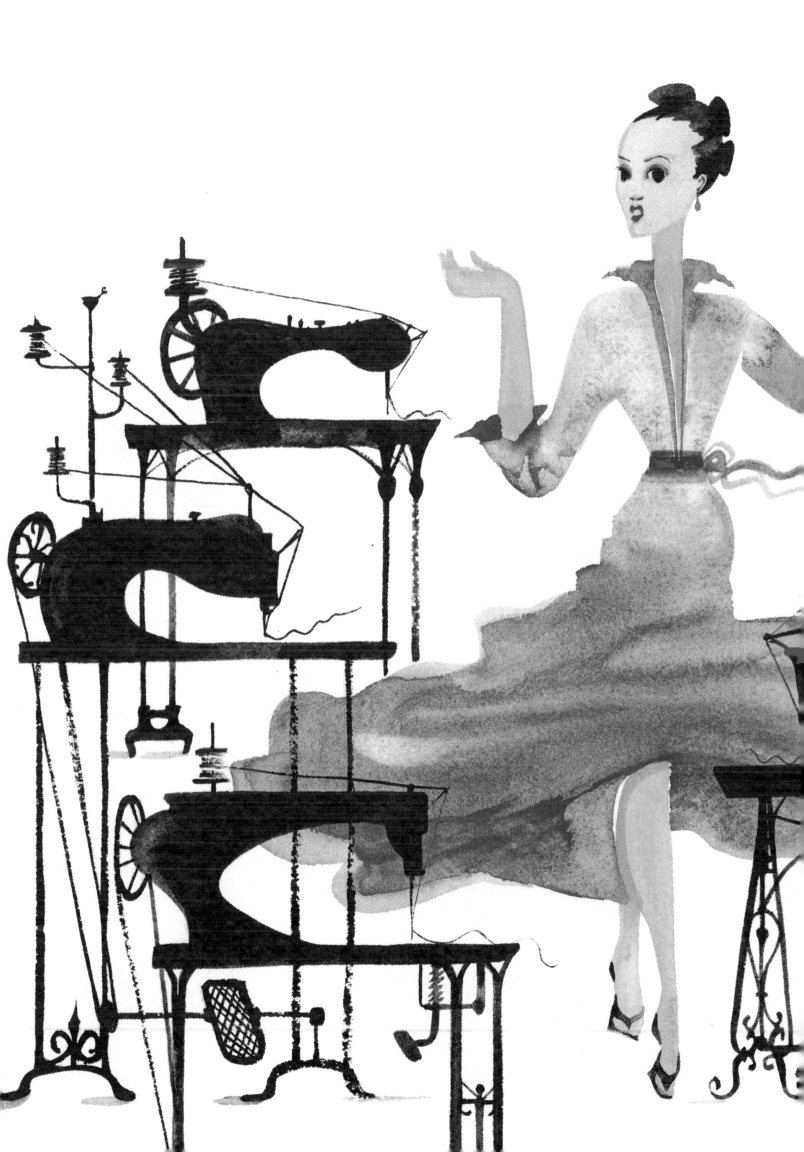

Isabel Toledo

(1960–2019) Cuban. Designer, founder of eponymous fashion label.

"Yes, I really do talk to my sewing machines."

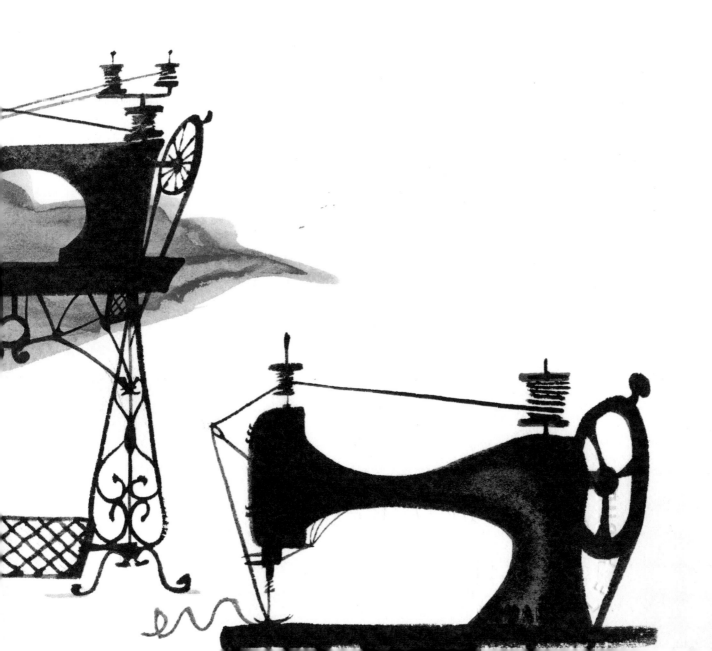

Ralph Rucci

(1957-) American. Founder of RR 331. Founder emeritus of Chado Ralph Rucci and Ralph Rucci.

"I would like to bring back a rigor of cut and *flou* and complicated simplicity that doesn't look messy."

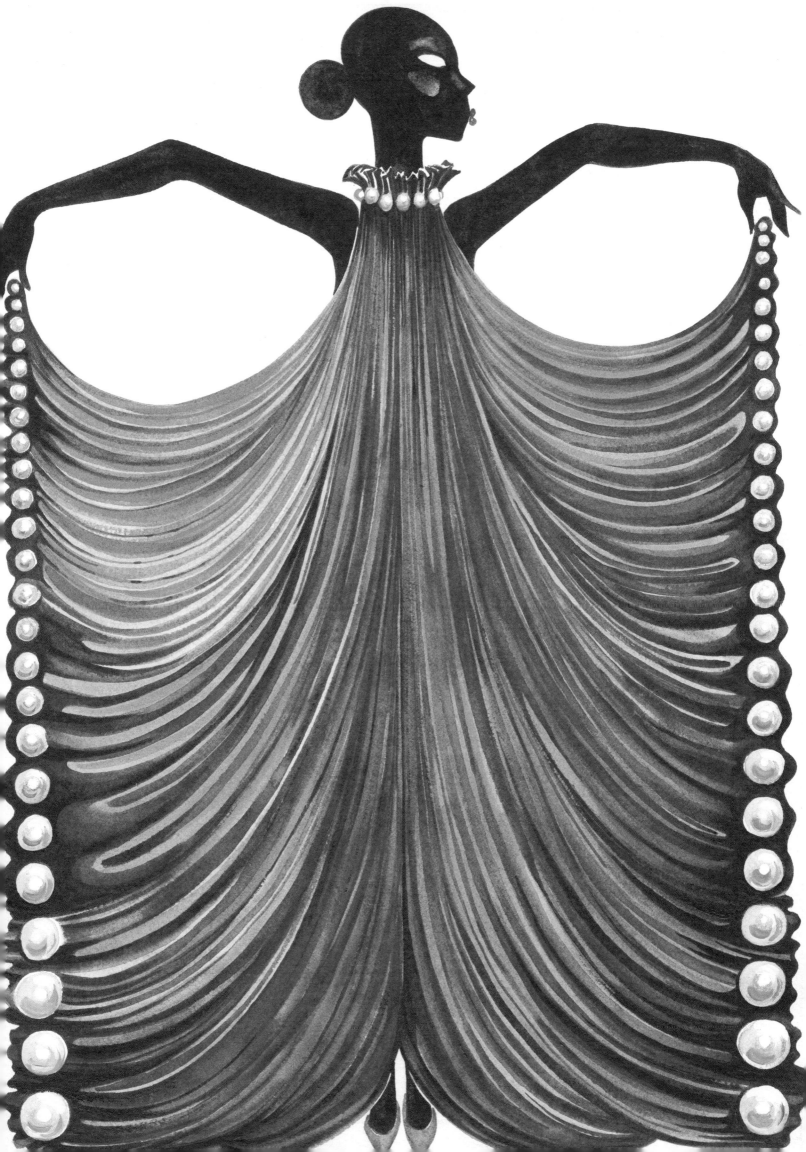

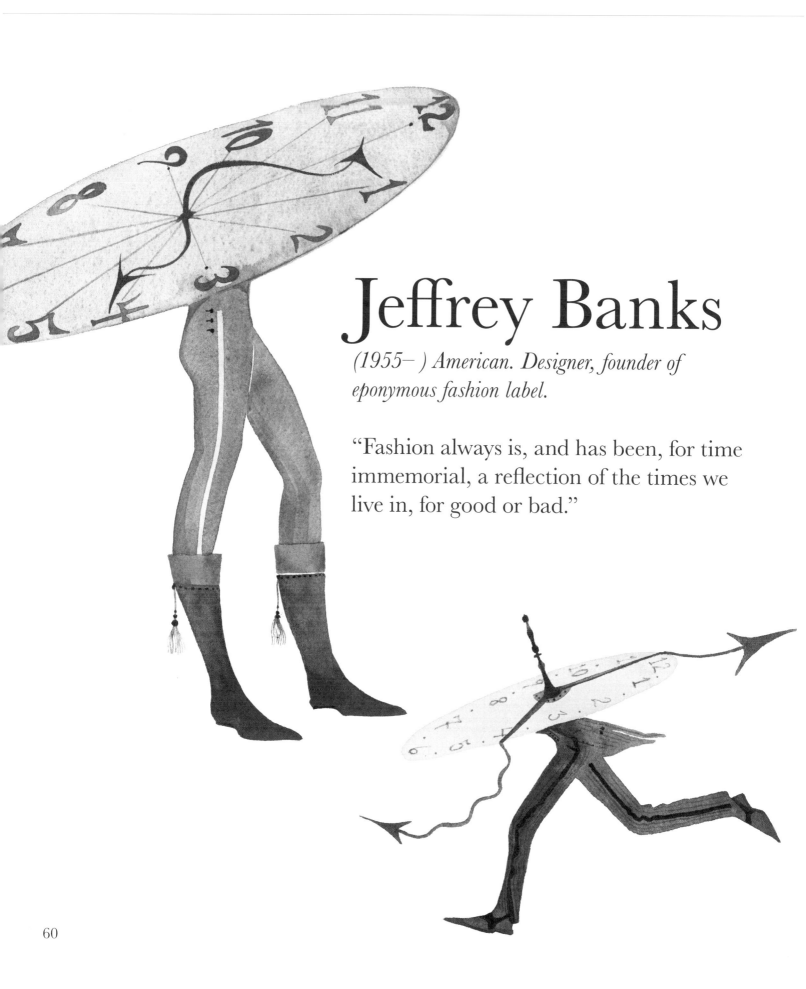

Jeffrey Banks

(1955–) American. Designer, founder of eponymous fashion label.

"Fashion always is, and has been, for time immemorial, a reflection of the times we live in, for good or bad."

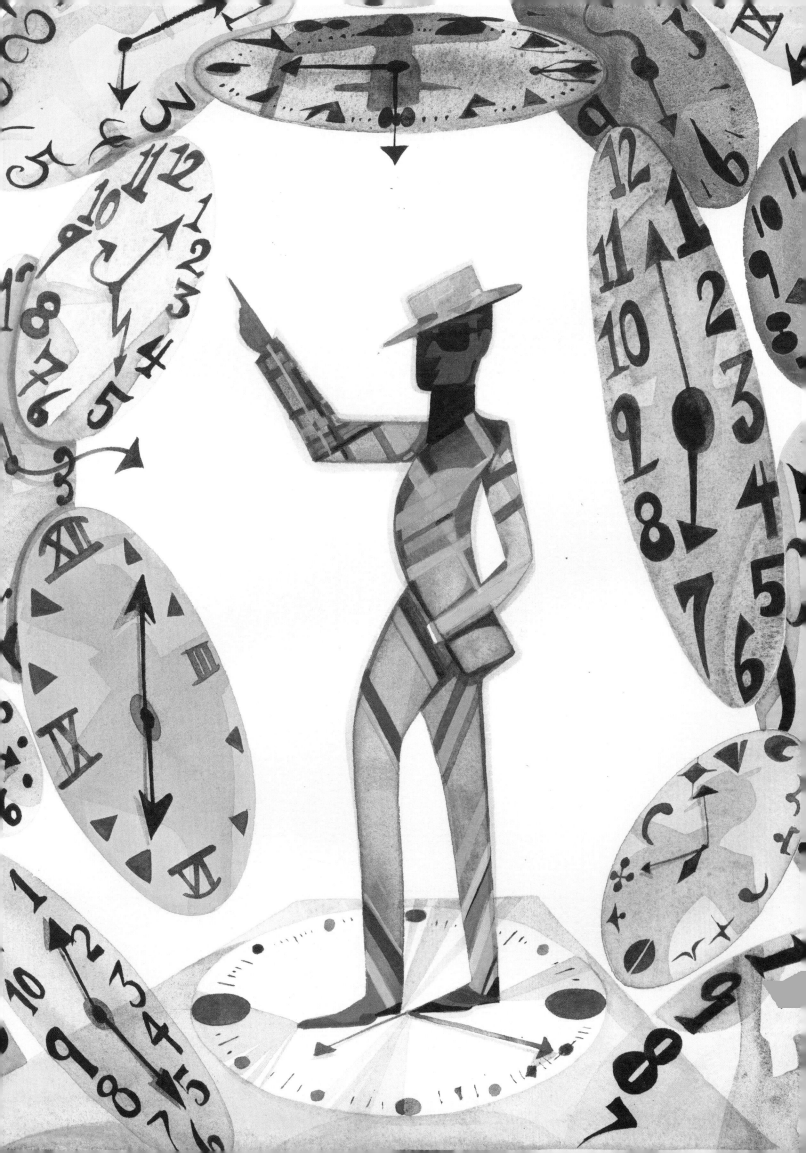

Christian Lacroix

(1951–) French. Designer, founder of eponymous fashion label.

"Until the eighteenth century, each period lived in its own creation. There was no looking back until Louis XVI. From the beginning of the nineteenth century fashion has taken the past as inspiration. In the 1910s, Paul Poiret's first famous numbers were Directoire. The late 1910s were romanticized nineteenth century updates. Christian Dior's New Look was an homage to his mother. The 1960s began as a relaunch of the 1920s."

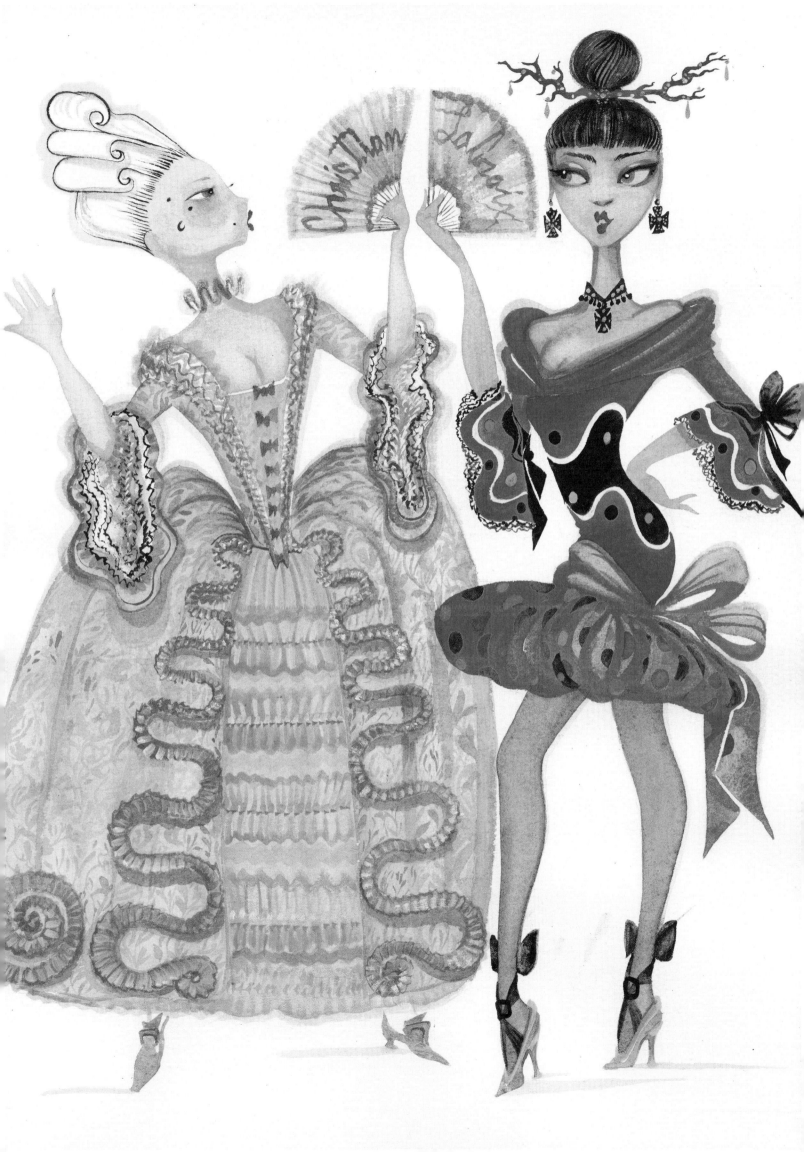

Valentino Garavani

(1932–) Italian. Designer, founder of Valentino fashion label.

"Italian fashion is more relaxed, more wearable. French fashion is full of fantasy and extremely feminine. American fashion is in the middle, taking from both."

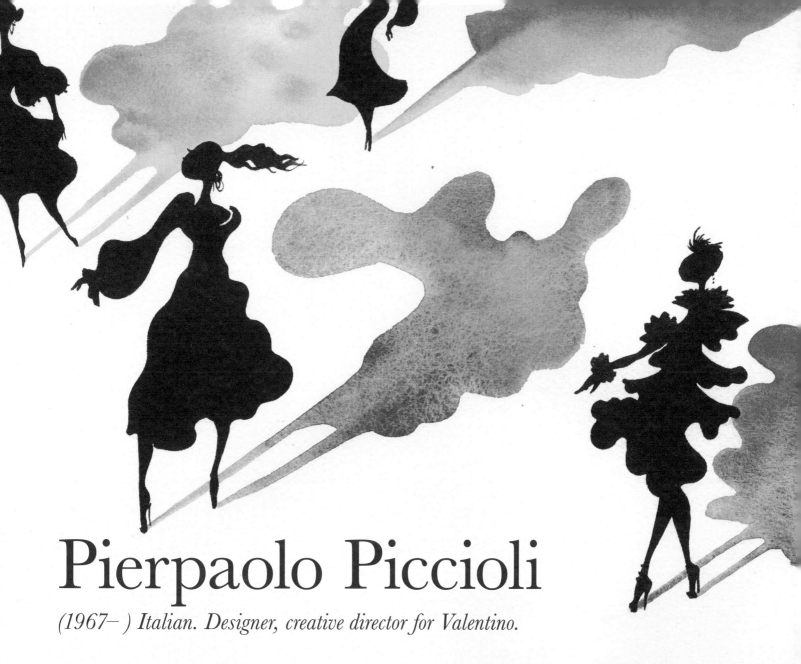

Pierpaolo Piccioli

(1967–) Italian. Designer, creative director for Valentino.

"We're talking a lot about inclusivity and diversity. I don't feel that we really have to talk about this. We have to do it. We have to act. We don't have to talk! We have the responsibility to allow people to dream. That's our job. We must stop the focus on marketing and numbers."

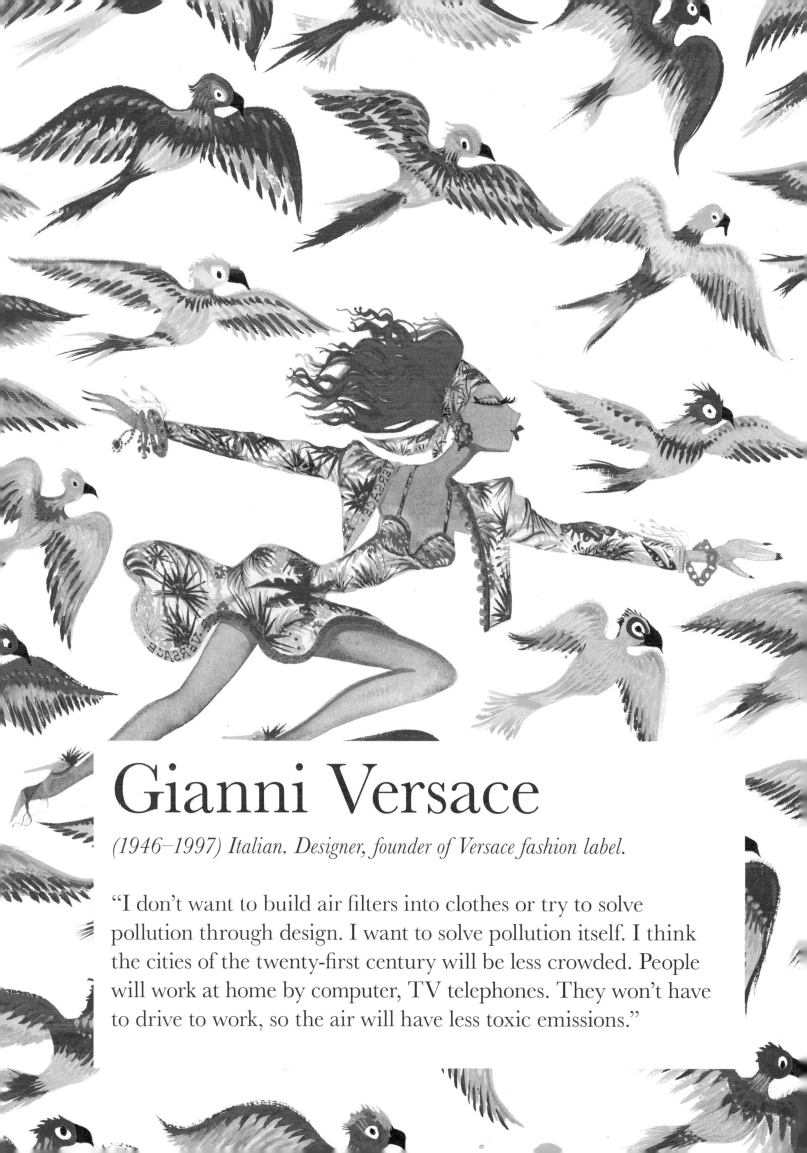

Gianni Versace

(1946–1997) Italian. Designer, founder of Versace fashion label.

"I don't want to build air filters into clothes or try to solve pollution through design. I want to solve pollution itself. I think the cities of the twenty-first century will be less crowded. People will work at home by computer, TV telephones. They won't have to drive to work, so the air will have less toxic emissions."

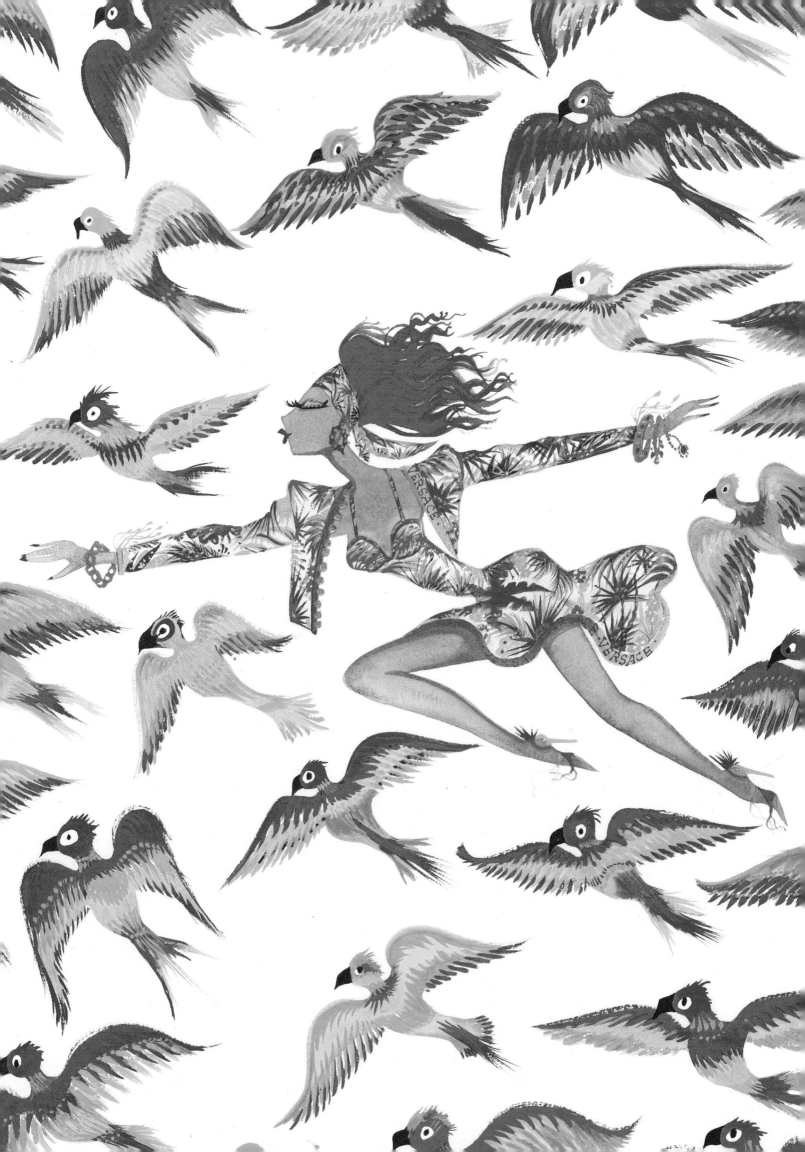

Azzedine Alaïa

(1935–2017) French. Designer, founder of Alaïa fashion label.

"There are no modern clothes. It's the way you wear them, the way you move in them, that makes them modern."

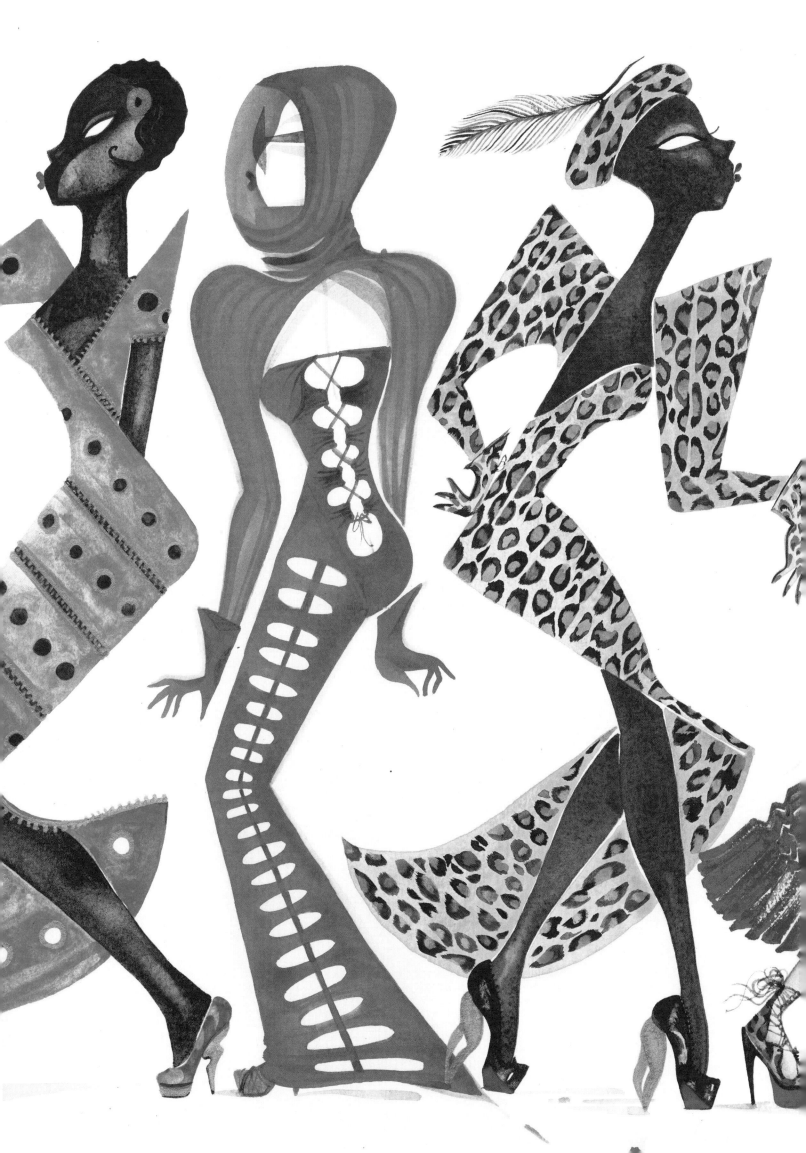

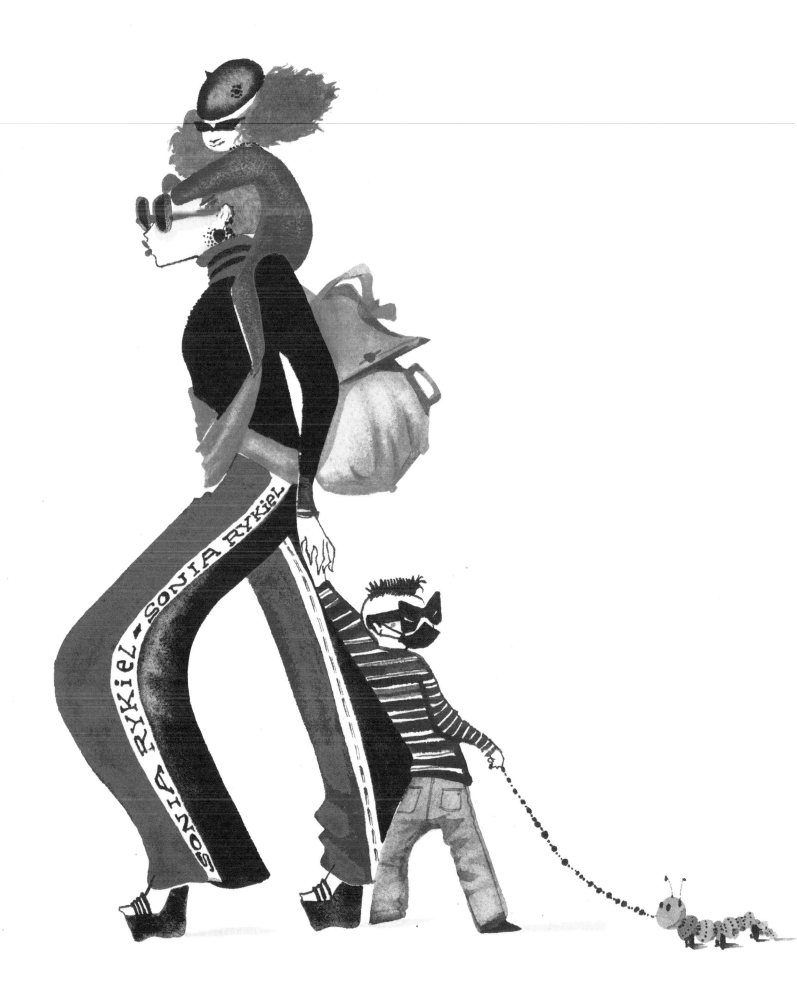

Sonia Rykiel

(1930–2016) French. Designer, writer, founder of eponymous fashion label.

"Can you believe they are saying pants are finished? We give women insecurity when we say 'Now you have to wear a miniskirt,' or 'Now pants are gone.' It's impossible to treat women like dolls. They will resist. A woman should be able to leave everything in one moment and take everything on her back—her child, her pillow, her clothes. It's the way—the only way—fashion interests me."

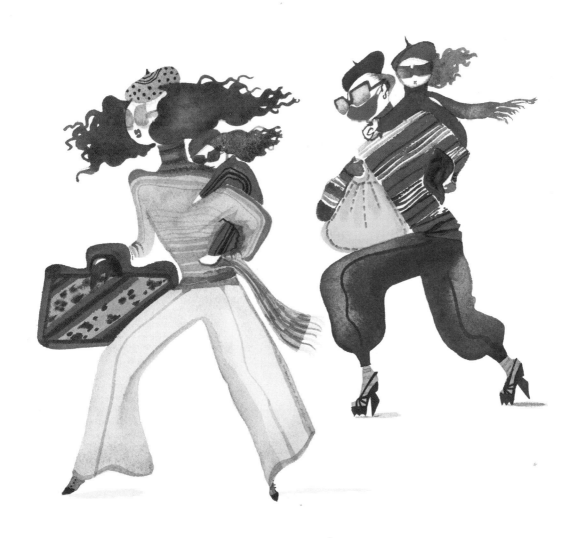

Thea Porter

(1927–2000) British. Designer, businesswoman.

"You called me the mother of the rich hippie look. I believe my abayas made women both beautiful and comfortable. Whatever else clothes may be about, I believe they must add to the enjoyment of life. A dress is a failure unless it gives a woman added confidence. She must put it on, feel great, and then forget that she is wearing it and get on with her life."

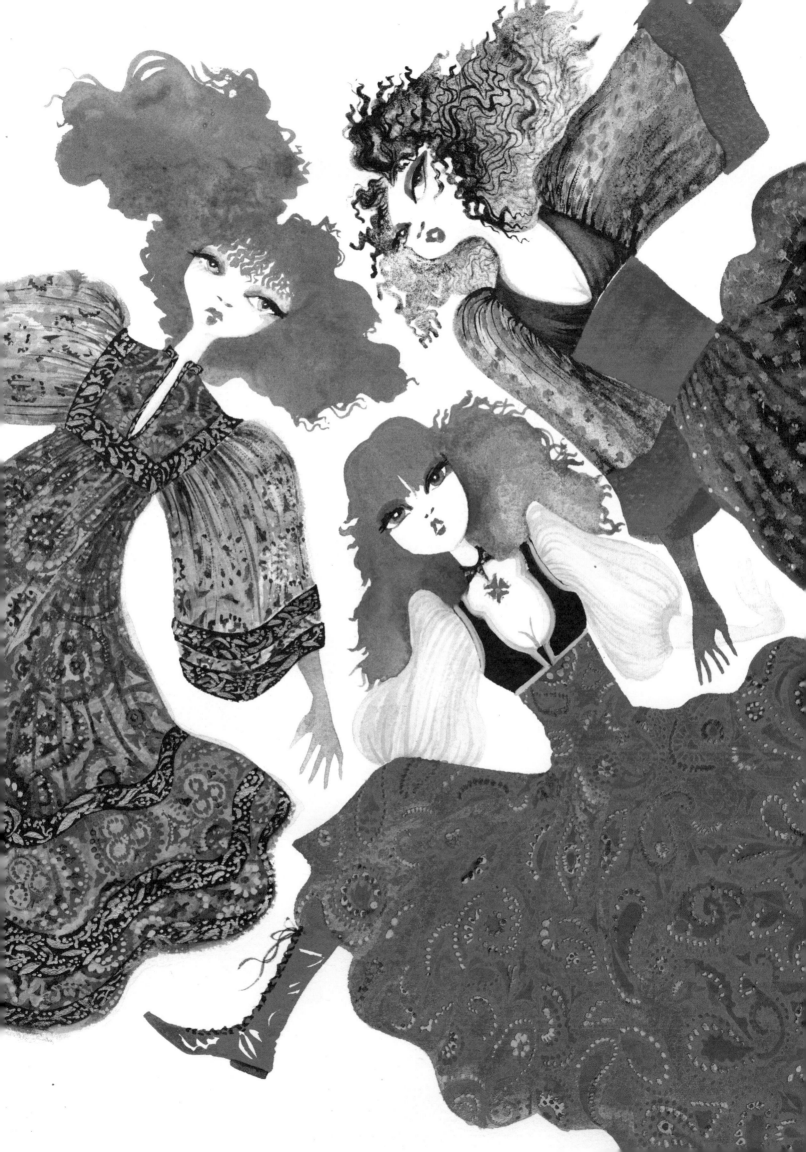

Zandra Rhodes

(1940–) British. Designer, founder of eponymous fashion label.

"Textile prints are my main forte, and it constantly amazes me how the print can control the whole look and shape of a garment. I suppose I'm the forerunner of the digital print revolution, as prints have always controlled the look of my garments before other designers could figure out how to do this. My clothes are engineered to accommodate the placement of the prints, rather than continuous, repetitive yardage."

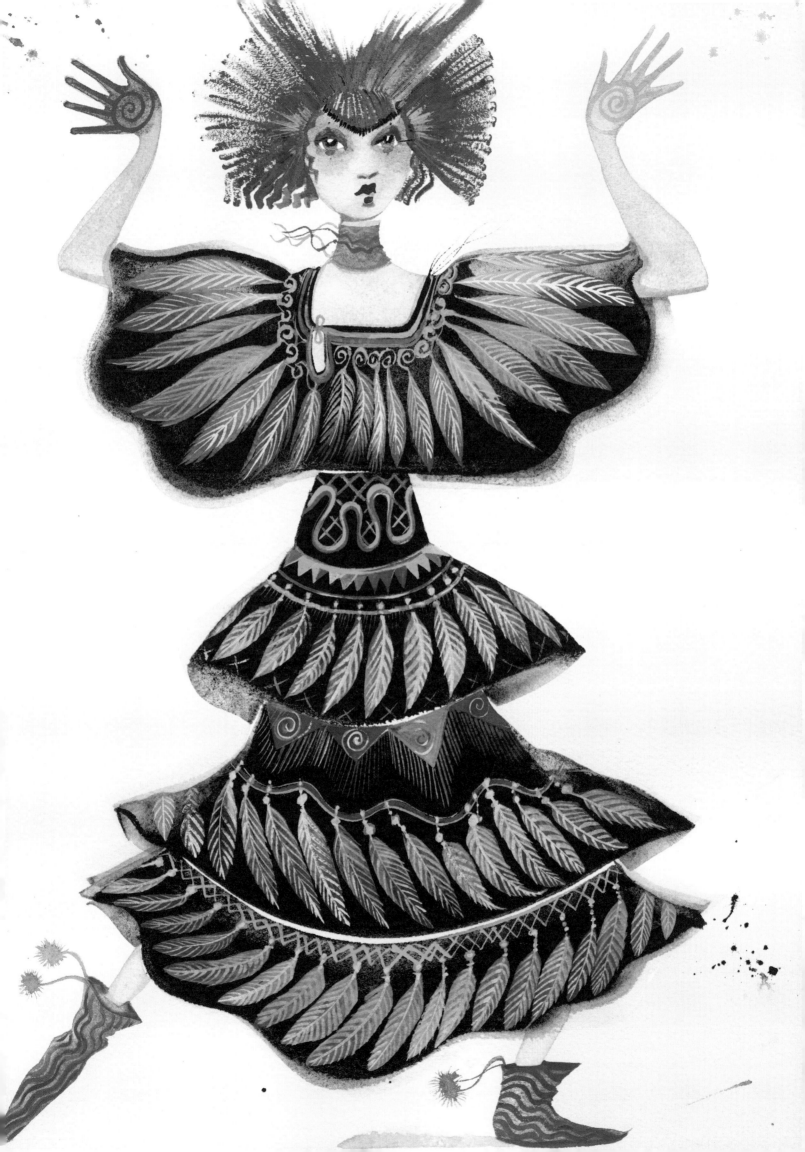

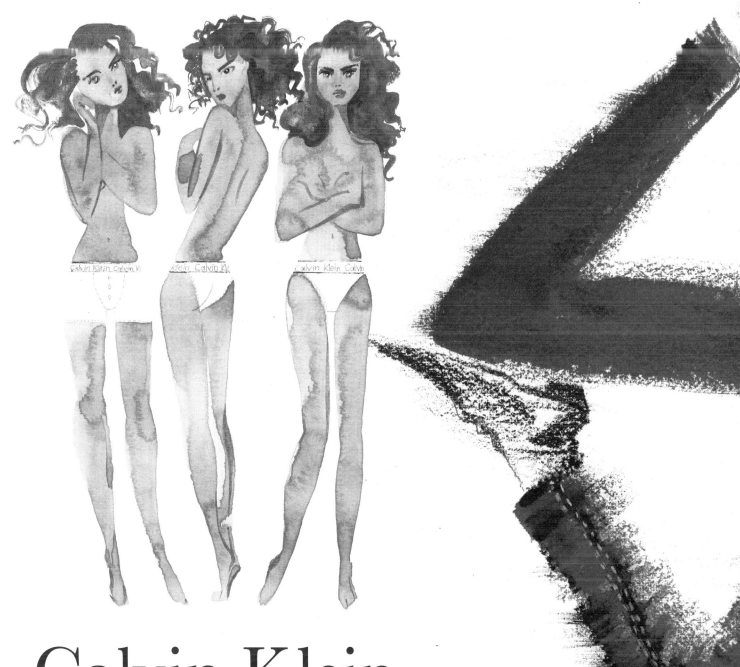

Calvin Klein

(1942–) American. Designer, founder of eponymous fashion label.

"I think there's something incredibly sexy about a woman wearing her boyfriend's T-shirt and underwear. Or a T-shirt and her Calvins."

Oscar de la Renta

(1932–2014) Dominican. Designer, founder of eponymous fashion label.

"When I told people I had apprenticed under Balenciaga, they would ask what I did there. It was very simple, I told them. I picked up pins on the floor. And when they asked what was the most surprising thing that happened when I went to Paris to design haute couture for Balmain, I told them of my total surprise when I walked into the atelier and there were no sewing machines."

Bill Blass

(1922–2002) American. Designer, founder of eponymous fashion label.

"To think fashion should take one direction is all wrong. We've existed for two decades on looks from two designers: Chanel and Balenciaga. There should be several acceptable ways of dressing. Maybe the new look is no look. Or, it's chic to be square again. Americans do this very well. Designing must be more specific, more individual, yet identifiable as yours. The frank pursuit of celebrities by designers has degenerated into a glorified swap meet—your publicity for my free dress."

Stephen Burrows

(1943–) American. Designer, founder of eponymous fashion label.

"Clothes should be fun and easy to move in. They're like toys for adults to play with."

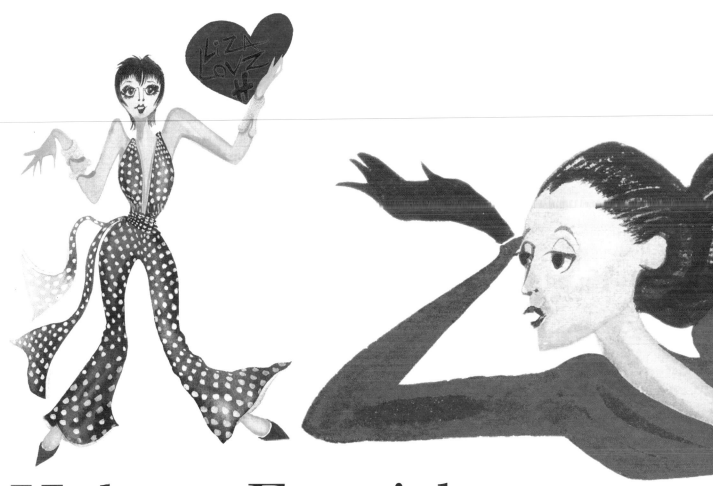

Halston Frowick

(1932–1990) American. Designer, founder of Halston fashion label.

"I think it's important to live in your own time frame—to do your own design for your own public. It's too easy to relate to something that's been worn before. It takes work to do something new. As I've said, you're only as good as the people you dress."

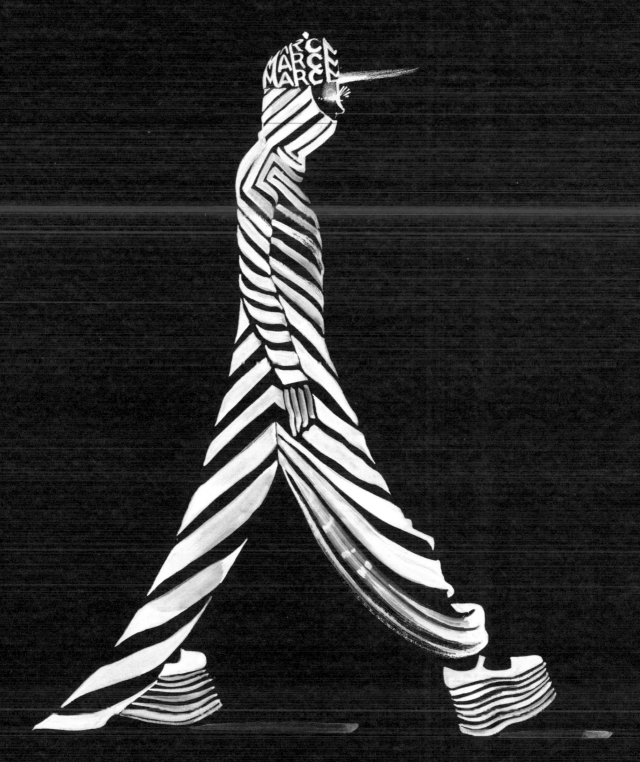

Marc Jacobs

(1963–) American. Designer, founder of eponymous fashion label. Creative director emeritus of Perry Ellis and Louis Vuitton.

"The customer is the final filter. What survives the whole process is what people wear. Clothes mean nothing until someone lives in them. I'm not interested in making clothes that end up in some dusty museum."

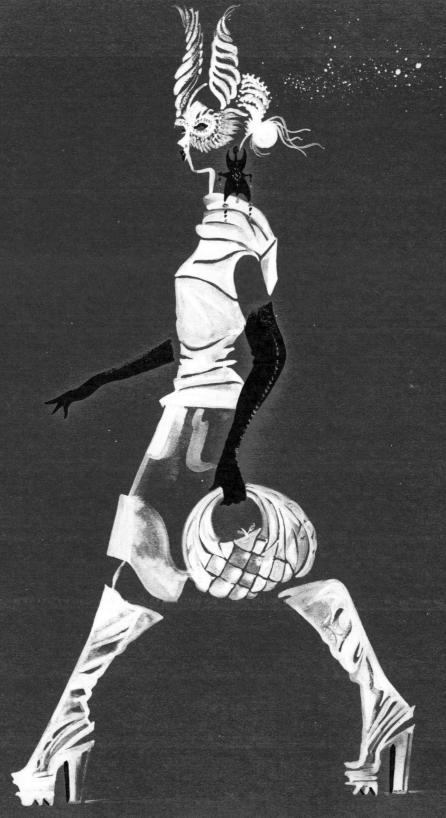

Virgil Abloh

(1980–2021) American. Designer, DJ, creative director for Louis Vuitton menswear, founder of Off-White fashion label.

"I analyze the modern girl—the girl that I'm friends with—and they're empowered. They pay their own bills, they have their own style. They wear clothes. The clothes don't wear them."

Christian Francis Roth

(1969–) American. Designer, founder of eponymous fashion label.

"The coronavirus pandemic has given me time to think about, among other things, the future of the fashion business. Even before this virus emerged, Millennials and Gen Z seemed more inclined to buy from smaller, more special designers, or buy vintage. They're interested in original design, authenticity, and brand storytelling, not to mention ethical and transparent business practices. They want to be part of

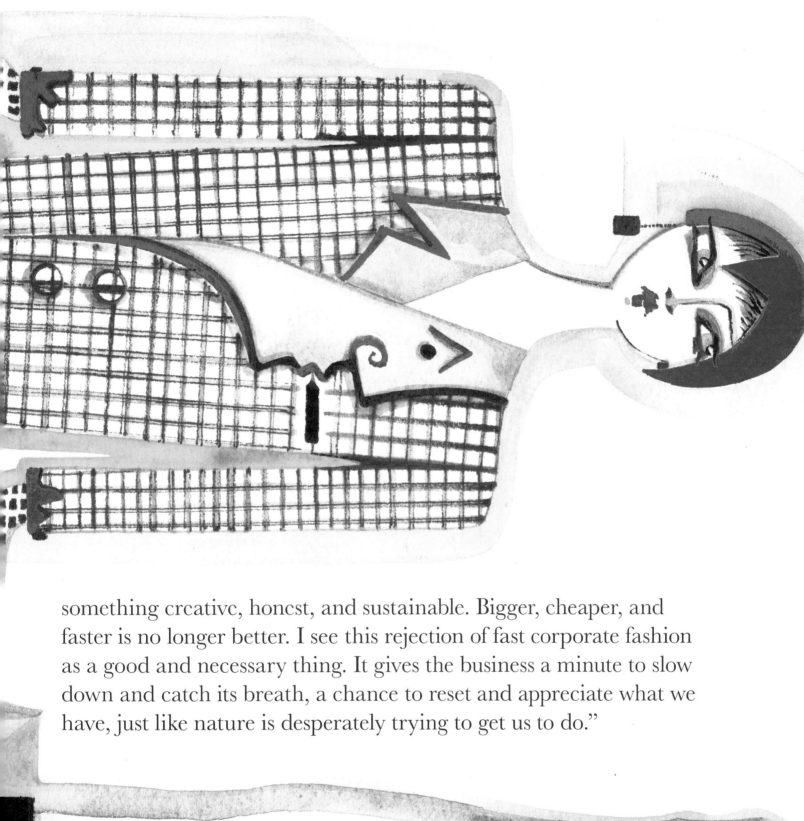

something creative, honest, and sustainable. Bigger, cheaper, and faster is no longer better. I see this rejection of fast corporate fashion as a good and necessary thing. It gives the business a minute to slow down and catch its breath, a chance to reset and appreciate what we have, just like nature is desperately trying to get us to do."

recycle
upcycle
Fashionupcycle

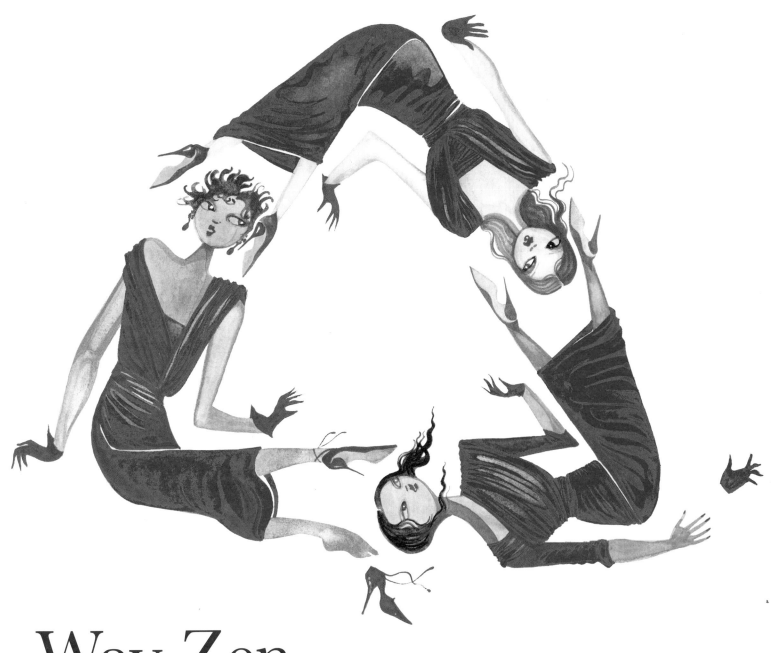

Way Zen

(1962–) Chinese. Designer, founder and owner of JSong.

"As an upcycler, I believe that yesterday's waste can lead to tomorrow's creativity. Taking apart and reconstructing vintage or existing stock items can be inspirational as well as ecological. Consciousness of our environment will always have its place."

Missoni

Rosita Missoni

(1931–) Italian. Designer, co-founder of Missoni fashion brand.

"We are artisans. Sometimes we happen to achieve good results in the field of applied art. But we do not think we are making art. And if there is something artistic about what we are doing, it is not up to us to say so."

Ottavio Missoni

(1921–2013) Italian. Designer, co-founder of Missoni fashion brand.

"Clothing should be for you, not for fashion or for this occasion or that. Therefore, these clothes have no season. They are timeless. More than fashion, they are for living."

Angela Missoni

(1958–) Italian. Executive director and president emeritus of Missoni brand.

"I think we're going back to a beautiful woman—a more beautiful, healthy girl."

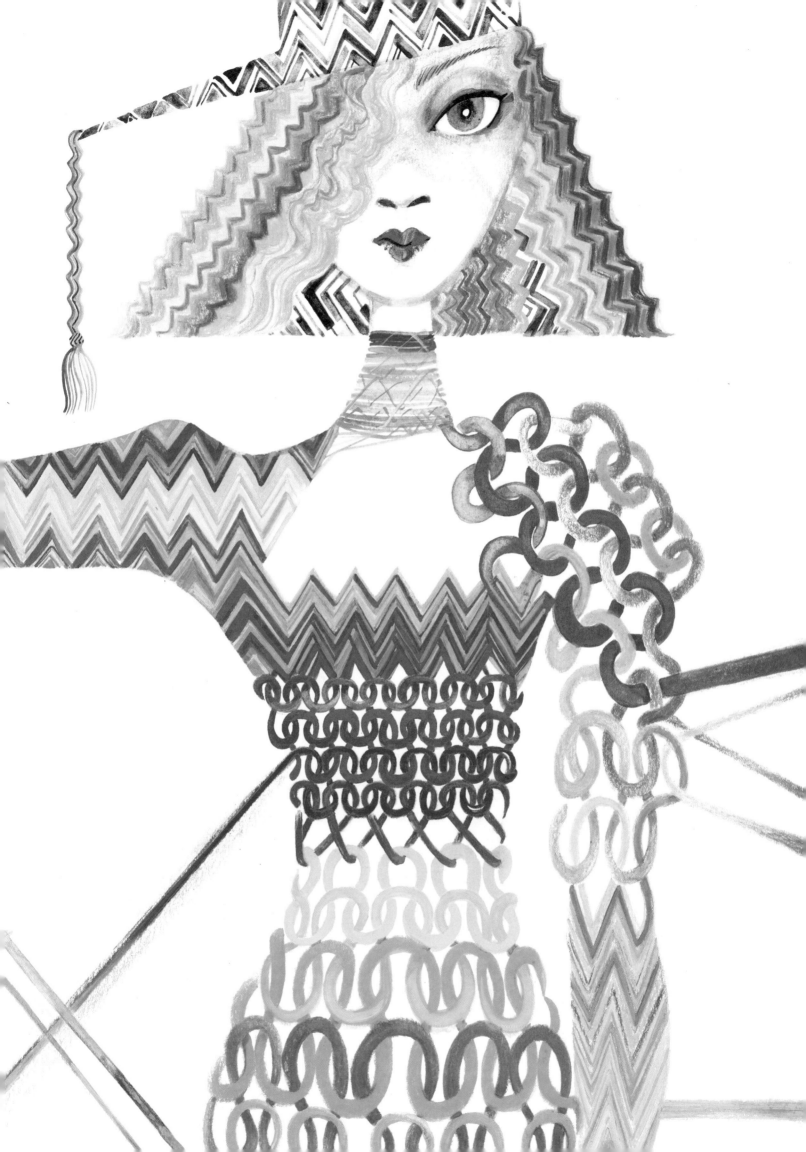

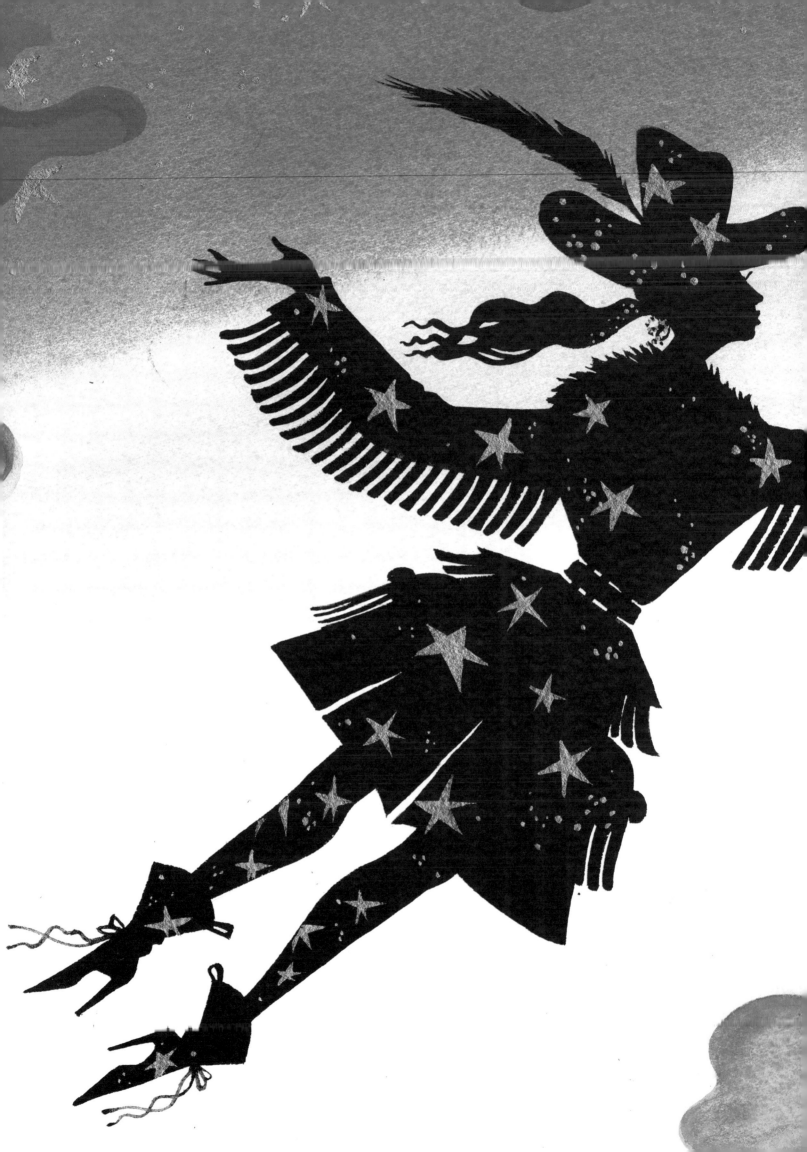

Ralph Lauren

(1939–) American. Designer, businessman, founder of eponymous fashion label.

"People ask how can a Jewish kid from the Bronx do preppy clothes. Does it have to do with class and money? It has to do with dreams. I don't design clothes; I design dreams."

Thierry Mugler

(1948–2022) French. Designer, founder of eponymous fashion label.

"Limiting populations is the only way to save our planet. The poorest countries make children because they need them. We must start there. We must use color to solve problems. Blue calms you. It's also generosity and holiness. Pale pink is perhaps the most calming color. Yellow gives us energy. Green is the earth. It's also the color of money. Purple is holiness and royalty. Amethyst is 'my' stone—the stone of Sagittarius."

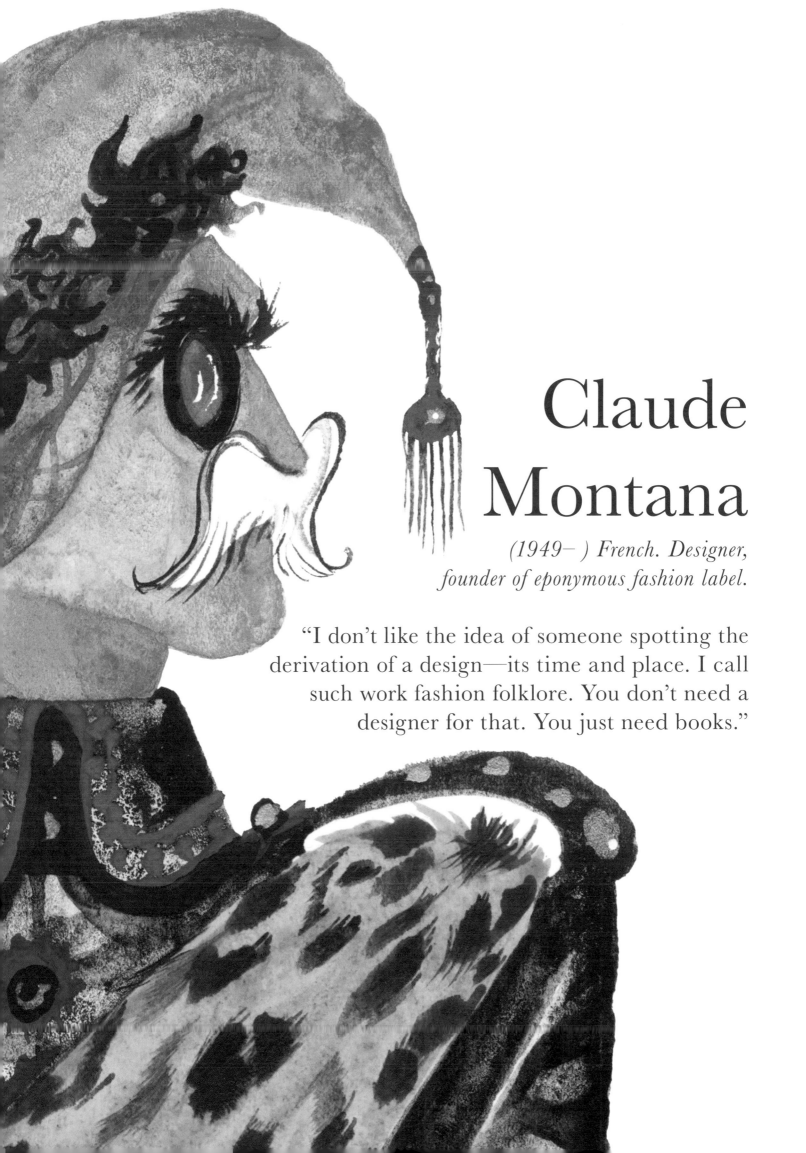

Claude Montana

(1949–) French. Designer, founder of eponymous fashion label.

"I don't like the idea of someone spotting the derivation of a design—its time and place. I call such work fashion folklore. You don't need a designer for that. You just need books."

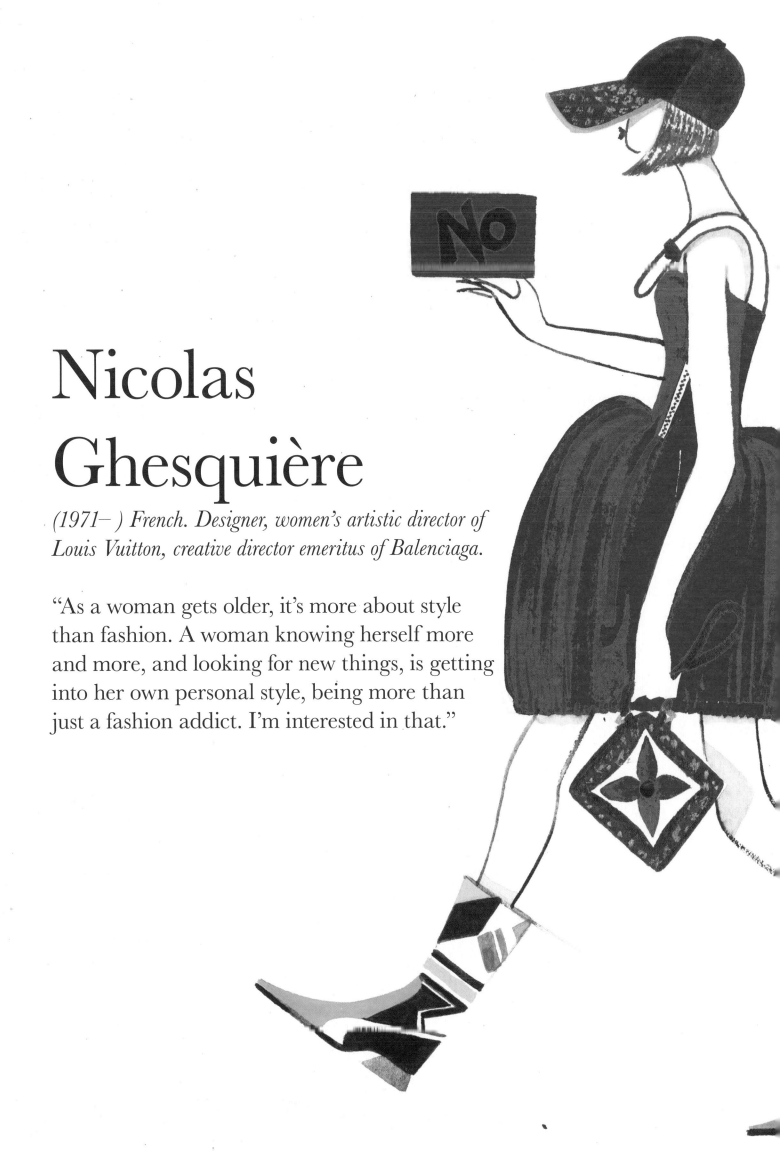

Nicolas Ghesquière

(1971–) French. Designer, women's artistic director of Louis Vuitton, creative director emeritus of Balenciaga.

"As a woman gets older, it's more about style than fashion. A woman knowing herself more and more, and looking for new things, is getting into her own personal style, being more than just a fashion addict. I'm interested in that."

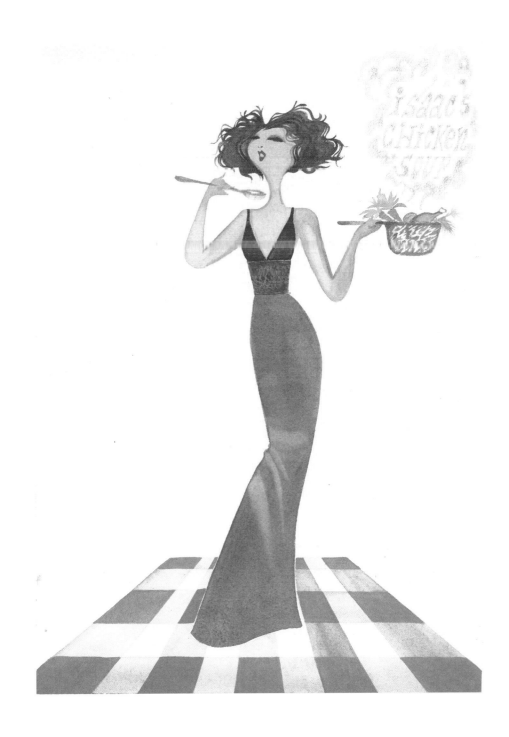

Isaac Mizrahi

(1961–) American. Designer, founder of eponymous fashion label.

"The appropriateness of appropriation can be compared to a classic chicken recipe. Both the original recipe and fashion's replays of classics can be updated by adding some spice."

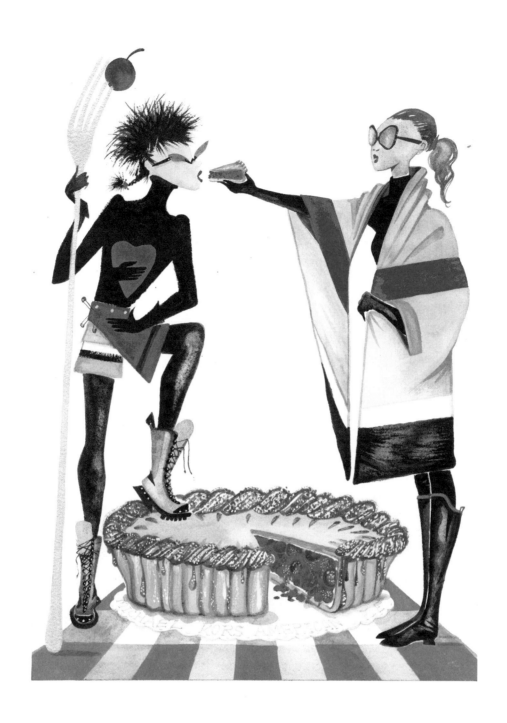

Michael Kors

(1959–) American. Designer, founder of eponymous fashion label.

"American pie. The birthplace of sportswear. The dichotomy of American style: prep versus punk, luxe versus relaxed, reimagined classics for modern times. Because of what's going on with the economy, I think women are realizing that maybe they don't need a closet full of clothes. They just need the right clothes."

Tommy Hilfiger

(1951–) American. Designer, founder of eponymous fashion label.

"I think it is really important to have a sense of business. As a designer, you can get so wrapped up in the design and fashion side that you forget the business side."

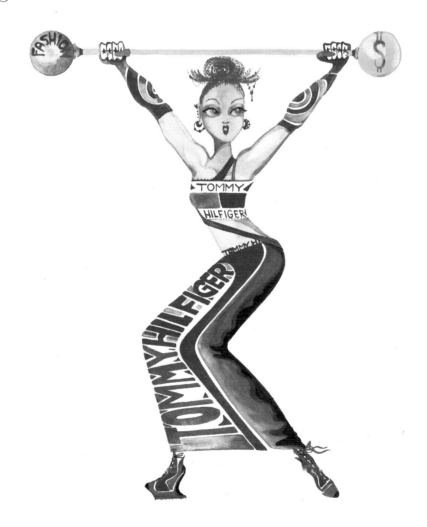

Rei Kawakubo

*(1942–) Japanese. Designer, founder of Comme des Garçons
and Dover Street Market.*

"What is beautiful or meaningful is not always determined by
the masses or conventional thought. Sometimes we are moved by
beauty in things that break the traditional sense of values. I always
try to break the rules with everything because no really new strong
creation ever didn't. I never intended any messages in my work, nor
will I do so in the future."

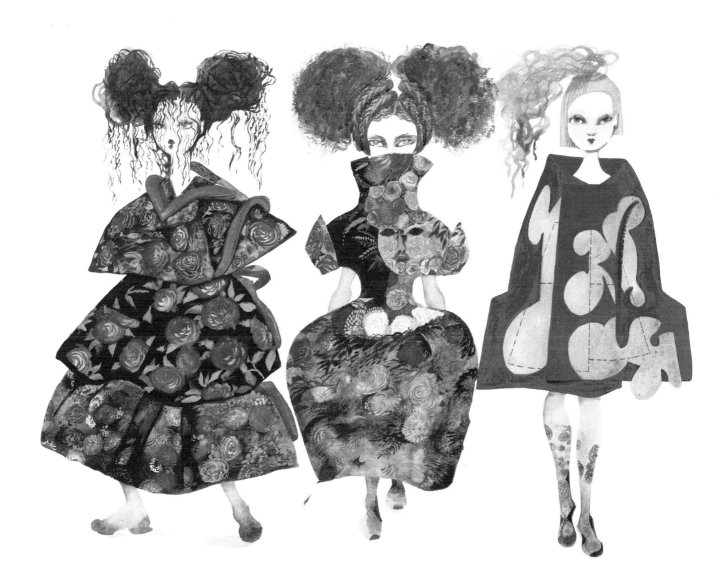

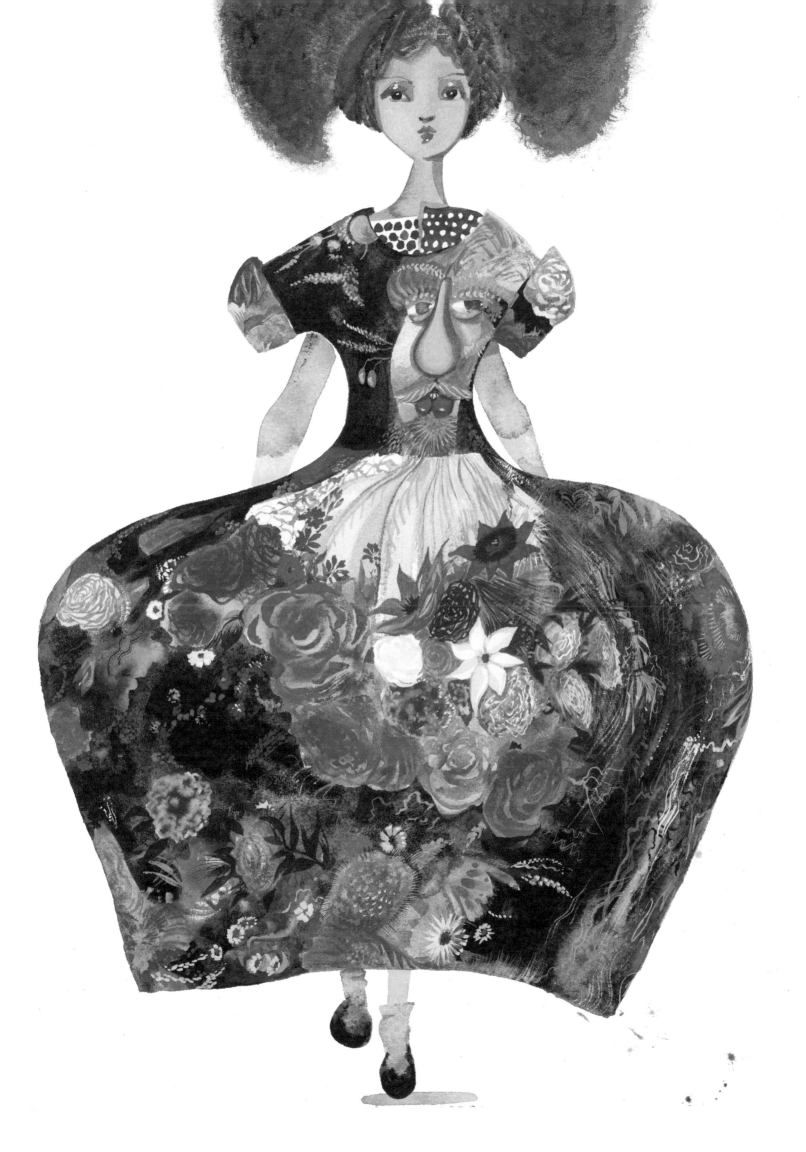

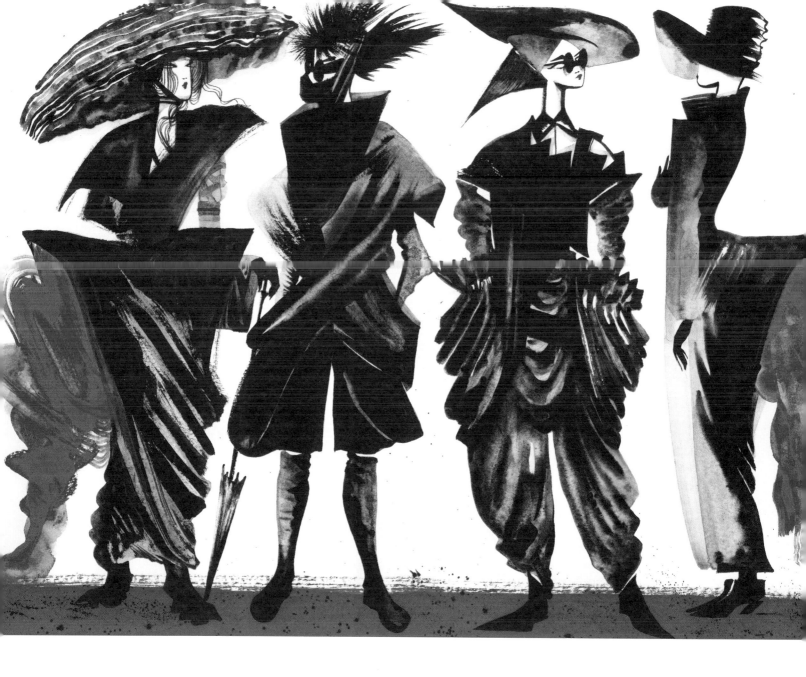

Yohji Yamamoto

(1943–) Japanese. Designer, founder of eponymous fashion label.

"I have been described as addicted to black. Why black, you may ask. Because black is modest and arrogant at the same time. Black is lazy and easy, but mysterious. You need black to have a silhouette. Black can swallow light or make things look sharp. But above all, black says this: I don't bother you; don't bother me."

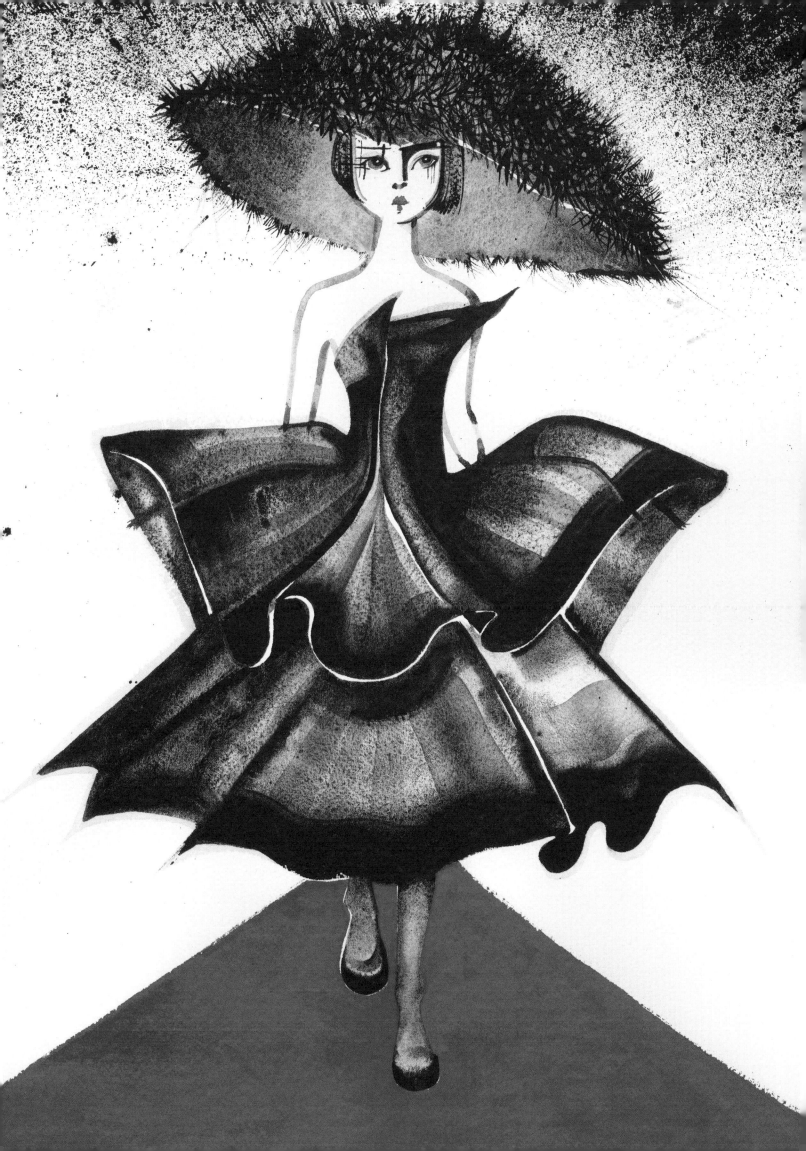

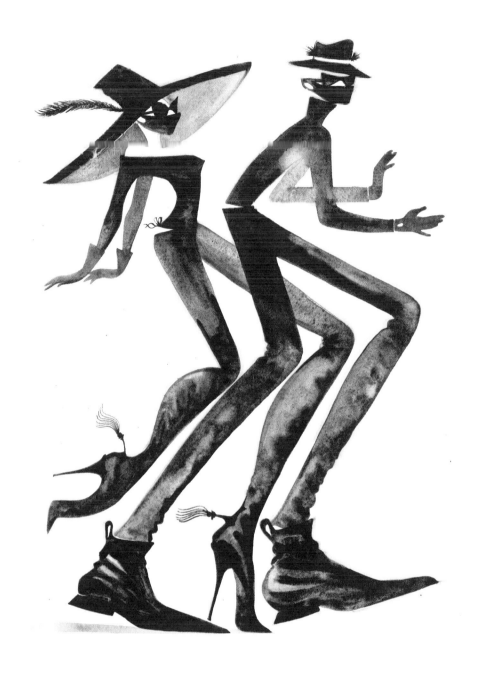

Hedi Slimane

(1968–) French. Designer, creative director for Celine, creative director emeritus for Dior Homme, Yves Saint Laurent.

"The shoes set up the tone and attitude. They change the perception of the way one wears clothes, what we call in France *le porte*. It is not about height, but the juxtaposition or *décalage* of the shoes—high or low—with the rest of the proportions."

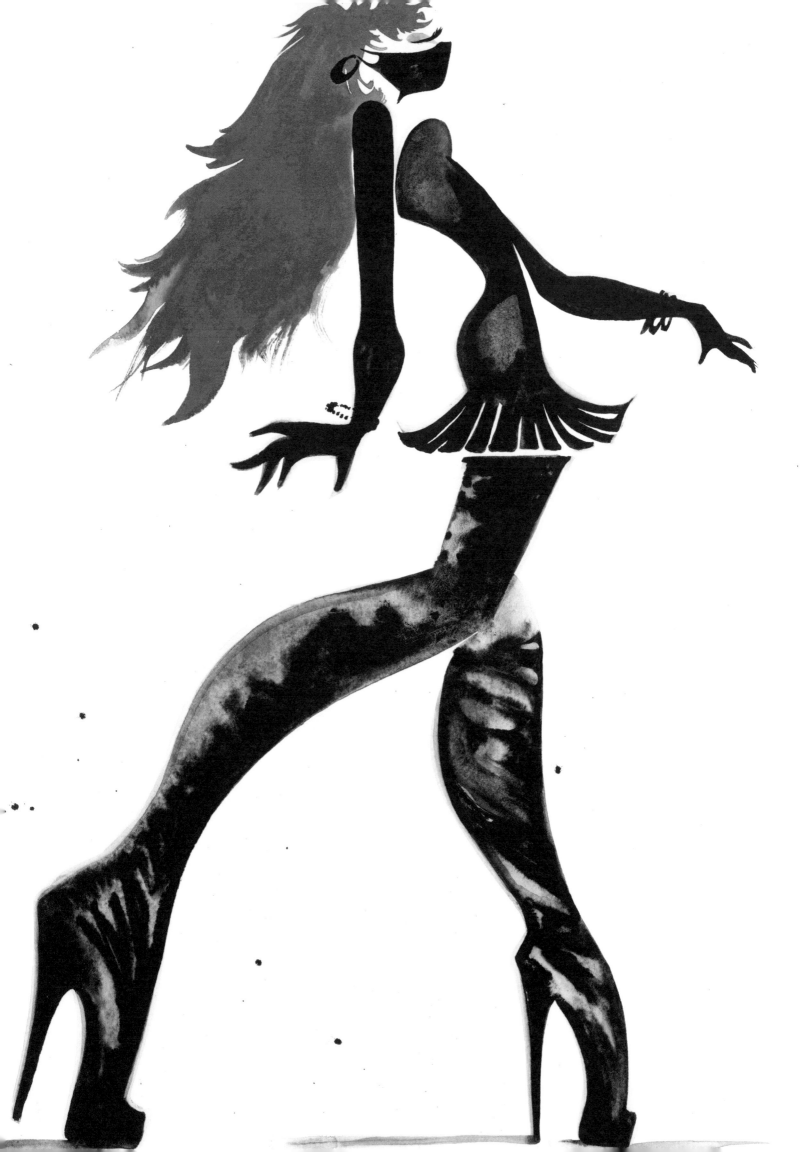

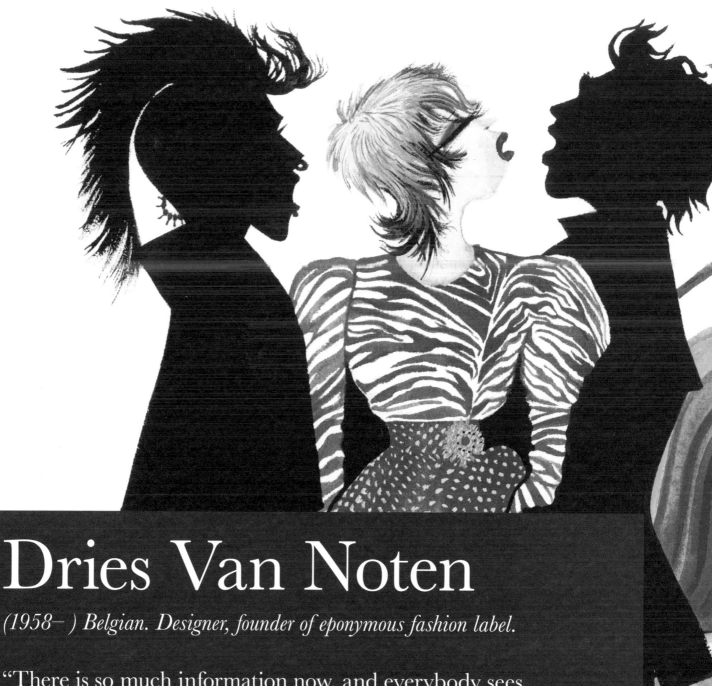

Dries Van Noten

(1958–) Belgian. Designer, founder of eponymous fashion label.

"There is so much information now, and everybody sees everything. When we were young kids, we really wanted to shock, but you have to remember, it was the time of punk, and there was a rebellion happening. It was a good thing. Now it's a bit more conventional."

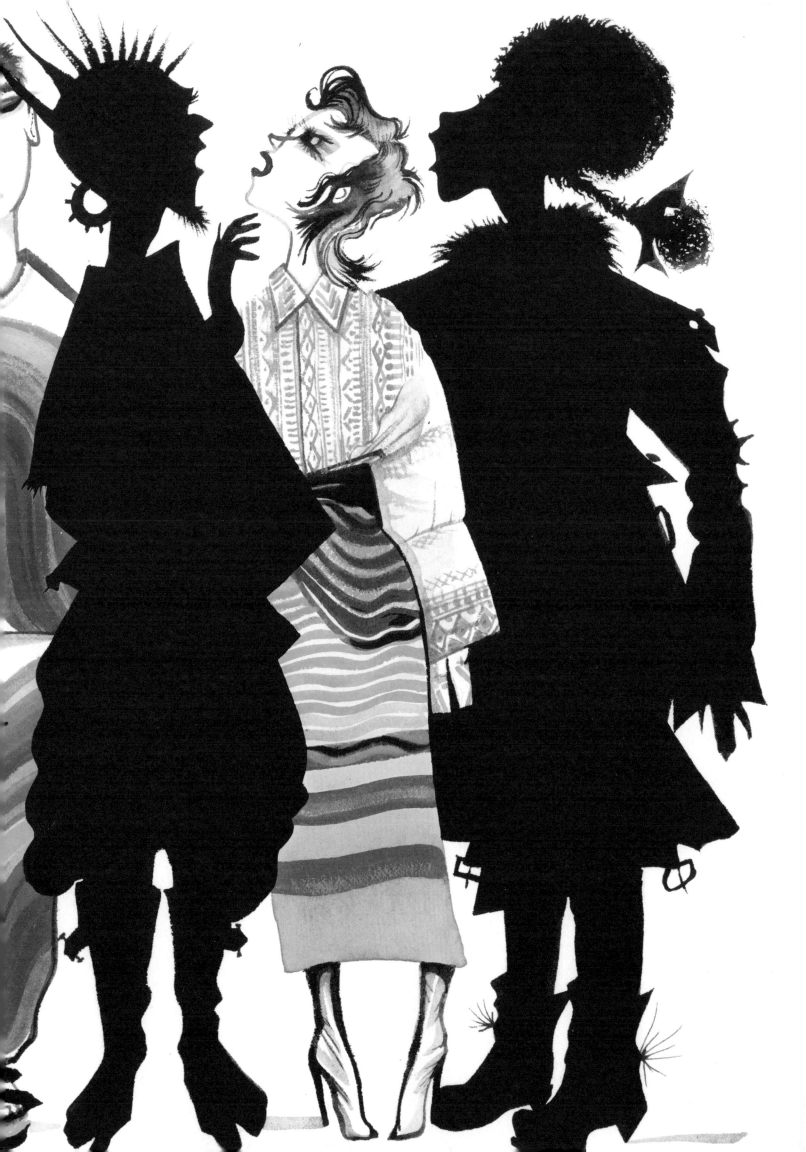

Phillip Lim

*(1973–) American. Designer, co-founder of
Development fashion label and founder of eponymous
fashion label.*

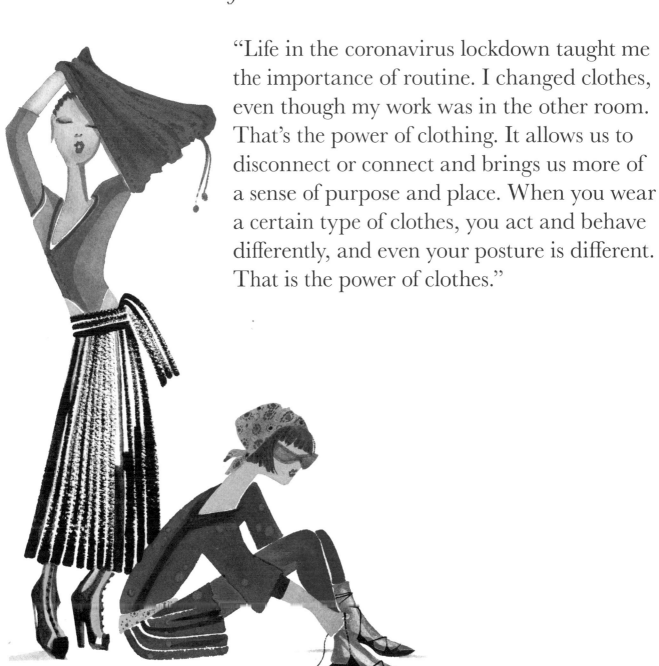

"Life in the coronavirus lockdown taught me
the importance of routine. I changed clothes,
even though my work was in the other room.
That's the power of clothing. It allows us to
disconnect or connect and brings us more of
a sense of purpose and place. When you wear
a certain type of clothes, you act and behave
differently, and even your posture is different.
That is the power of clothes."

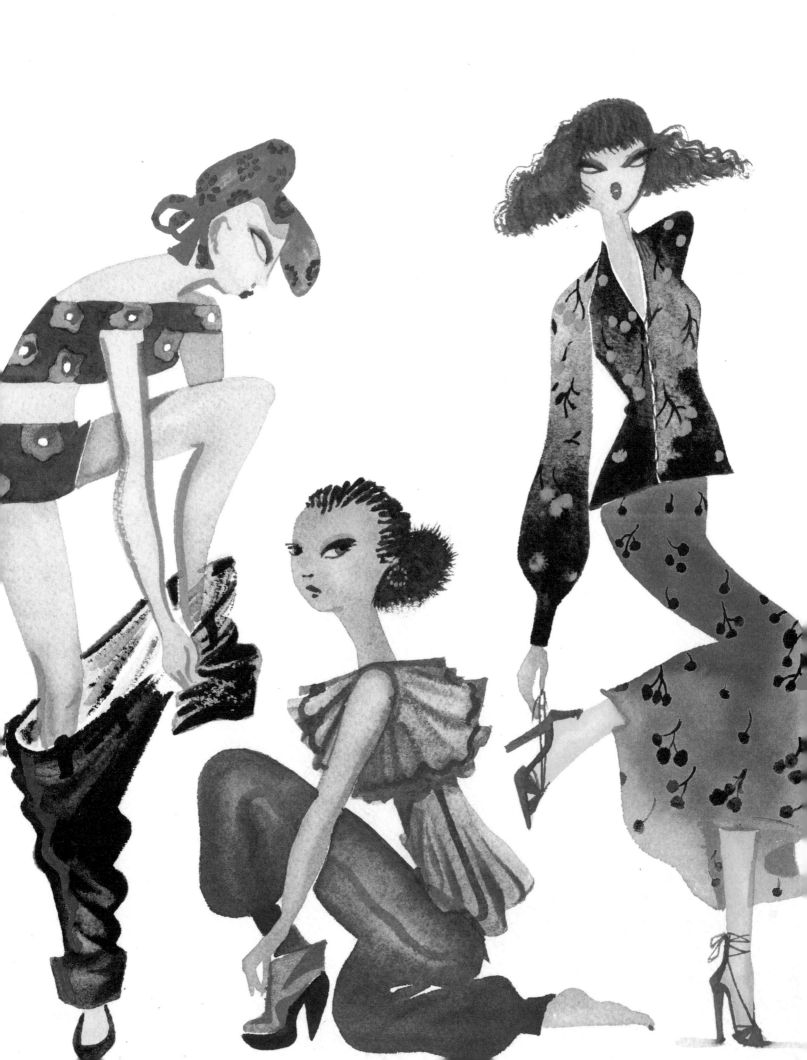

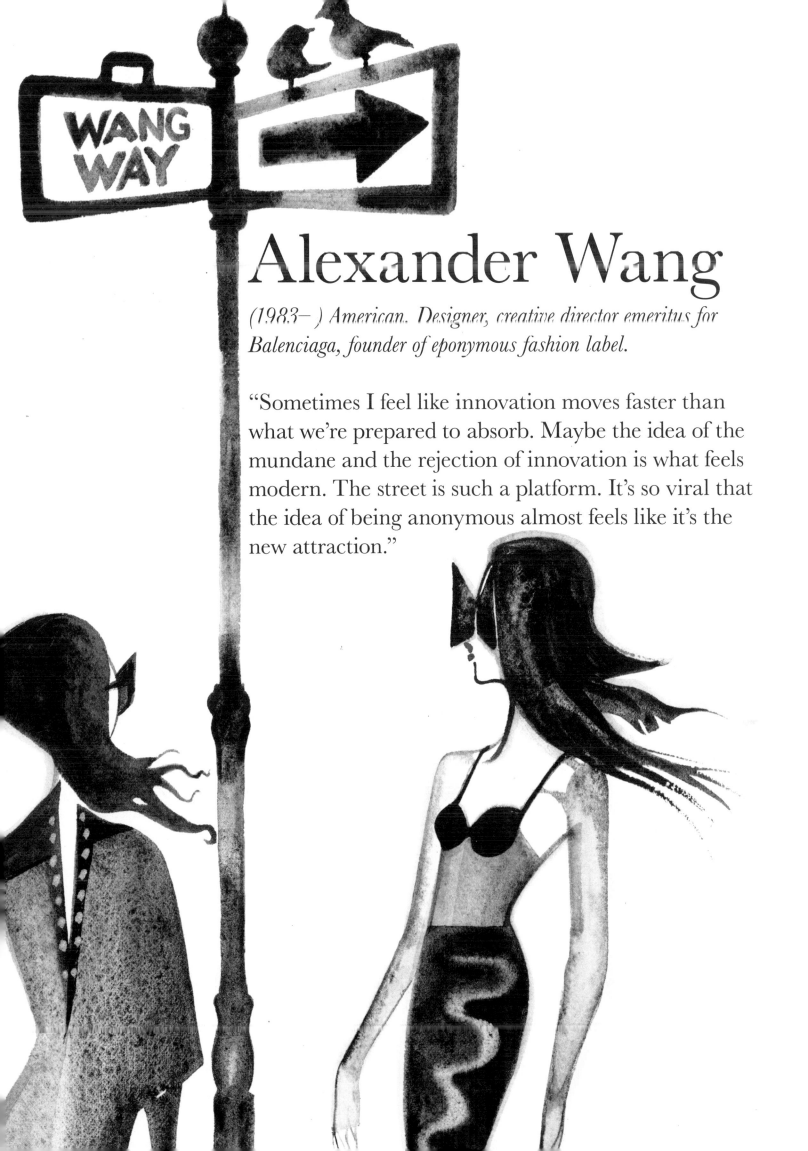

Alexander Wang

(1983–) American. Designer, creative director emeritus for Balenciaga, founder of eponymous fashion label.

"Sometimes I feel like innovation moves faster than what we're prepared to absorb. Maybe the idea of the mundane and the rejection of innovation is what feels modern. The street is such a platform. It's so viral that the idea of being anonymous almost feels like it's the new attraction."

Alber Elbaz

(1961–2021) Israeli. Founder, creative director for AZ Factory,
creative director emeritus for Lanvin and Yves Saint Laurent.

"When we designers became creative directors we had to
become image makers. We had to make sure everything
looks good in pictures. The screen has to scream, baby.
So loudness became the new thing. Loudness is the new
new, and not only in fashion. I prefer whispering. I think
it goes deeper and lasts longer."

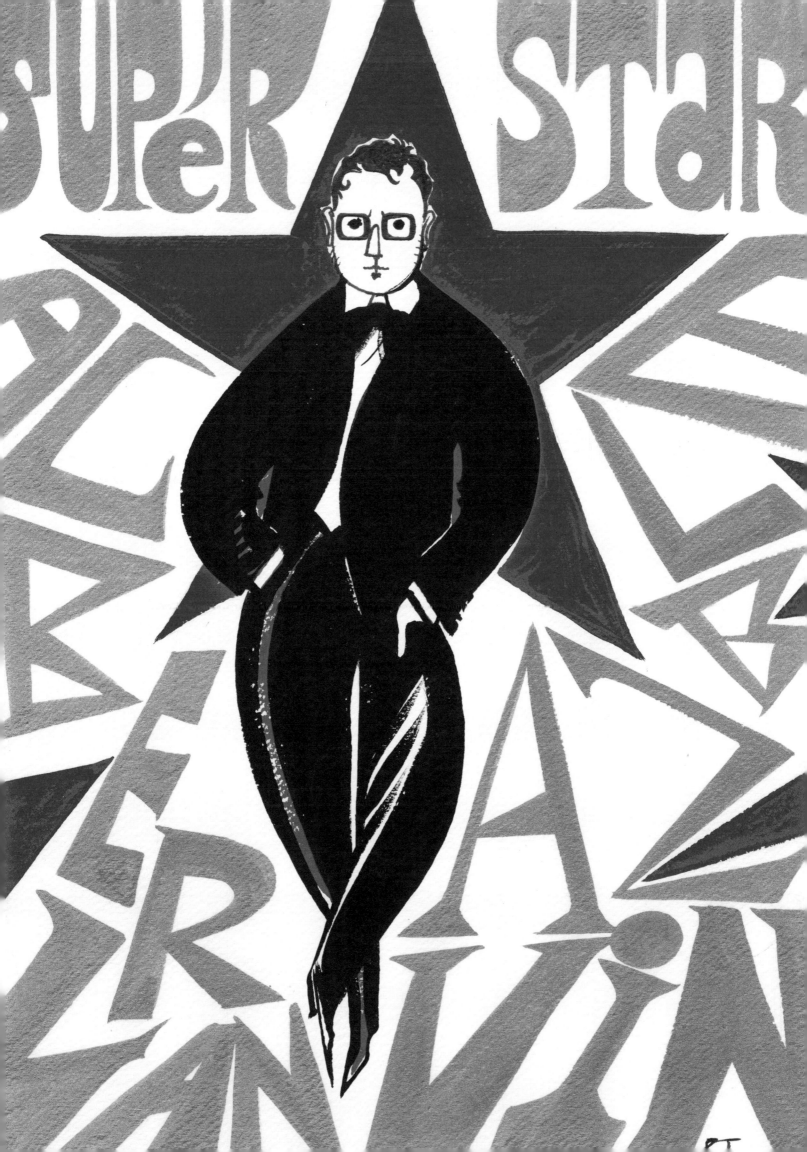

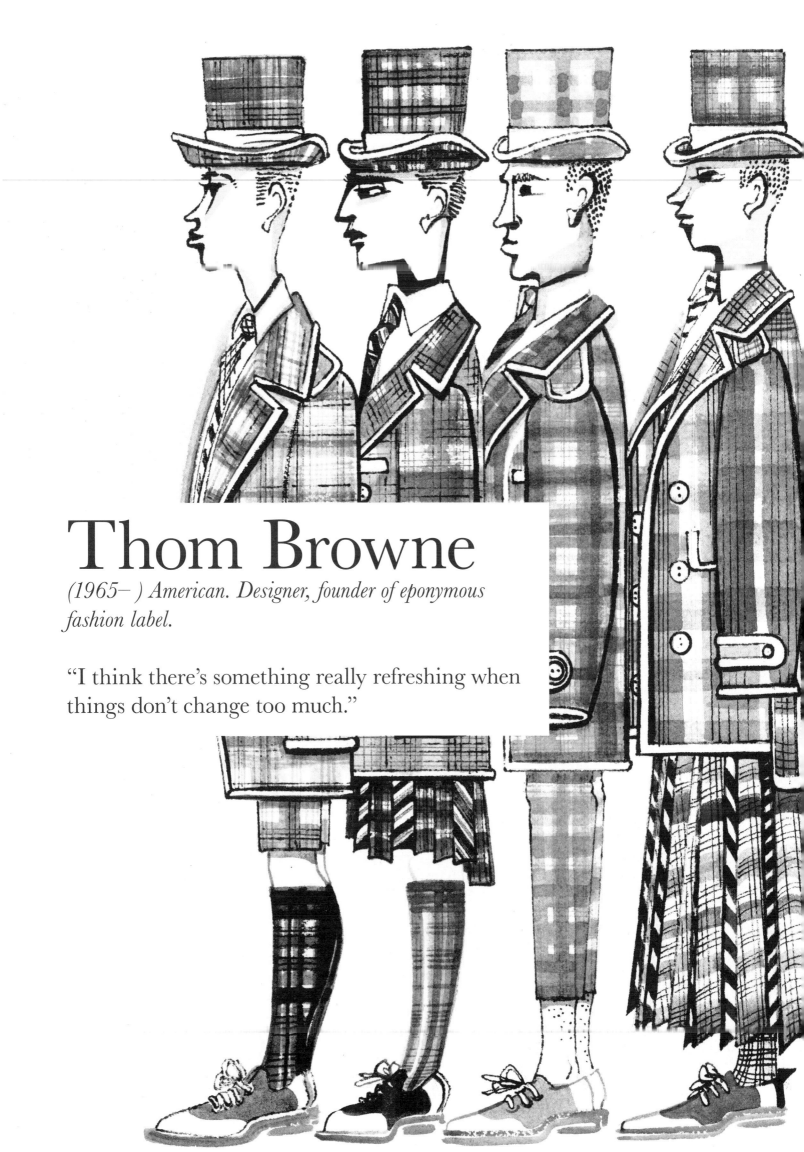

Thom Browne

(1965–) American. Designer, founder of eponymous fashion label.

"I think there's something really refreshing when things don't change too much."

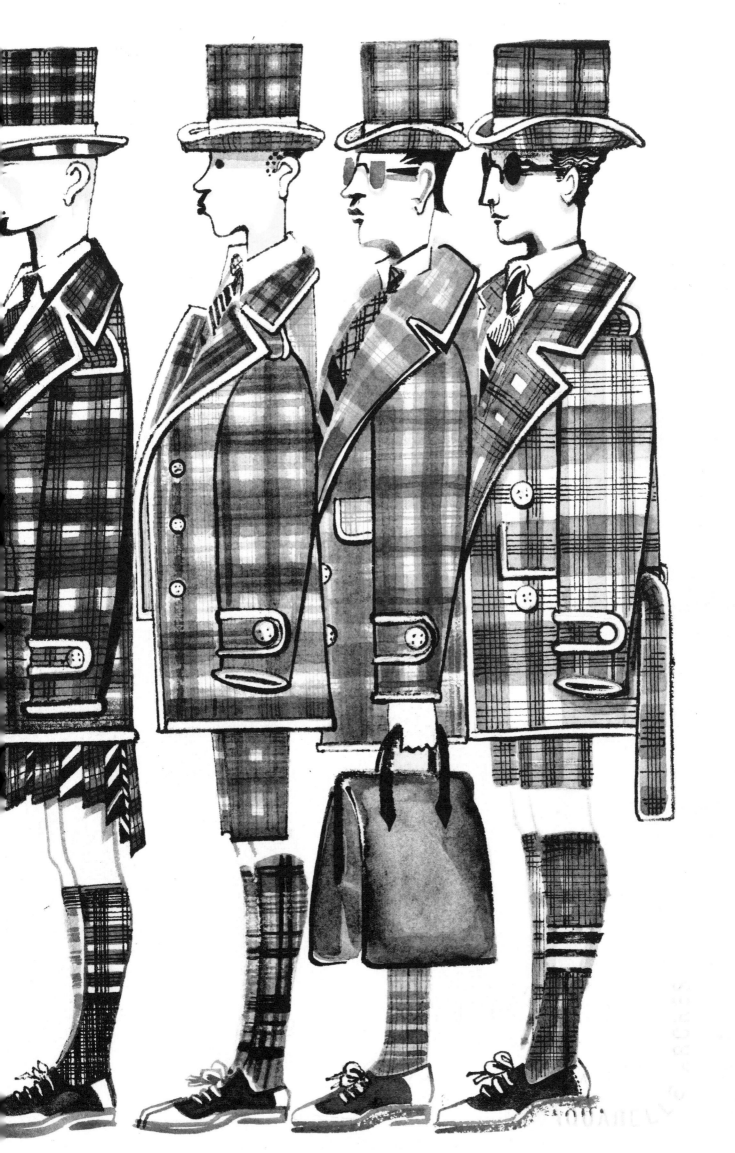

Diane von Furstenberg

(1946–) Belgian. Designer, founder of eponymous fashion label, CFDA chairman emeritus.

"The idea of being able to go to Studio 54 alone is what thrilled me the most—a man's life in a woman's body."

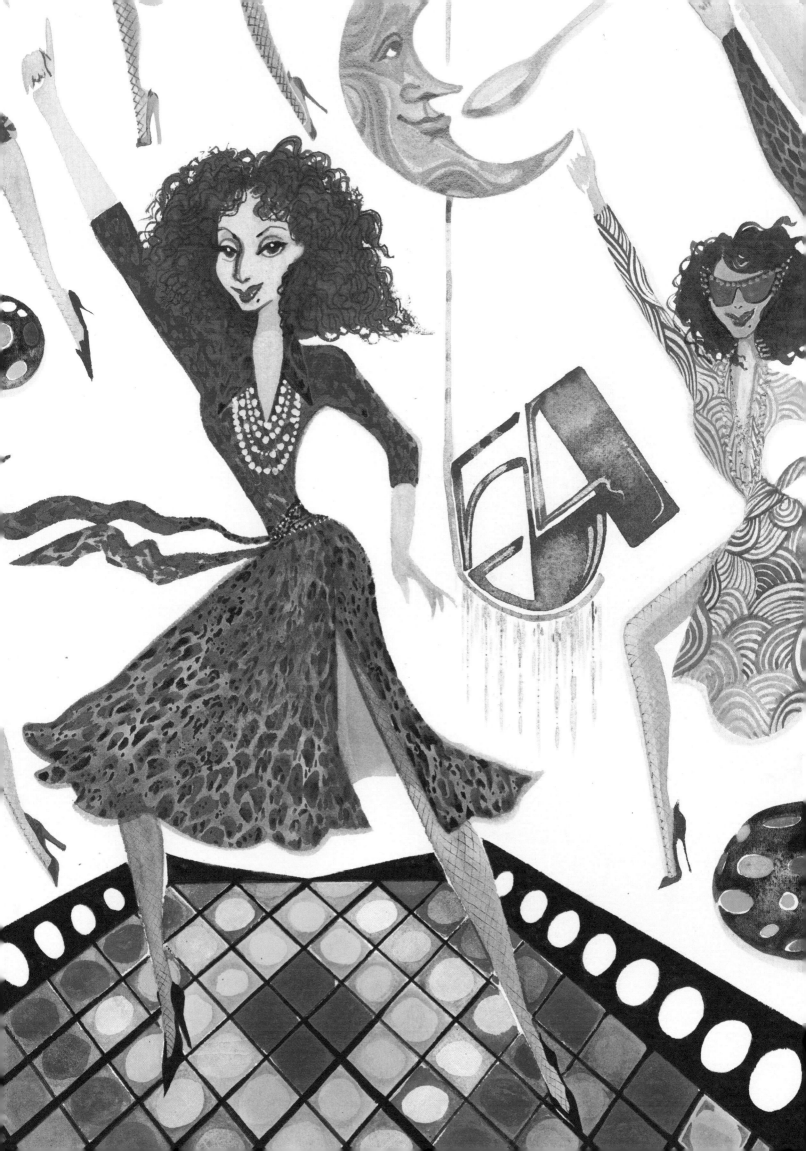

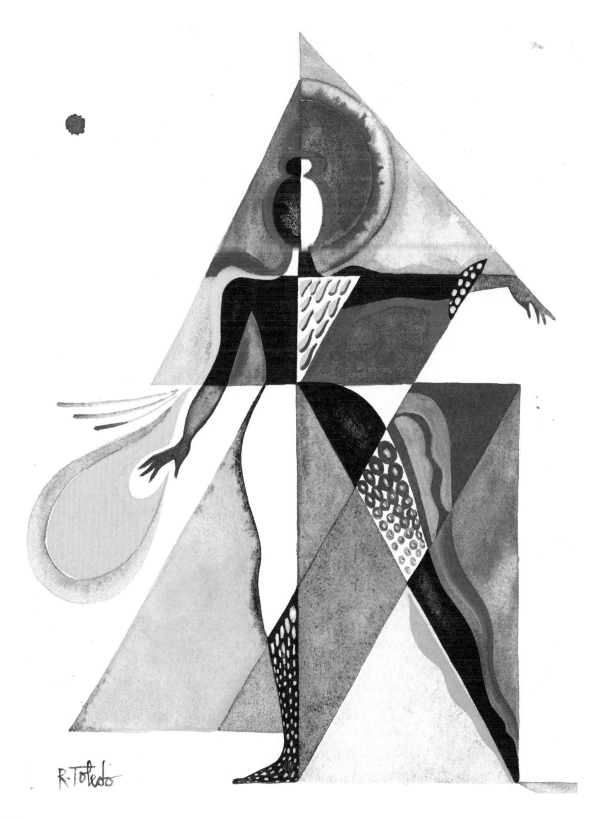

R.Toledo

Han Feng

(1962–) Chinese. Designer, artist, founder of eponymous fashion label.

"One of the biggest joys I find from design is to find geometric shapes and silhouettes that come alive through movement as we wear them, and the result is that it also makes our body, our every move, more elegant."

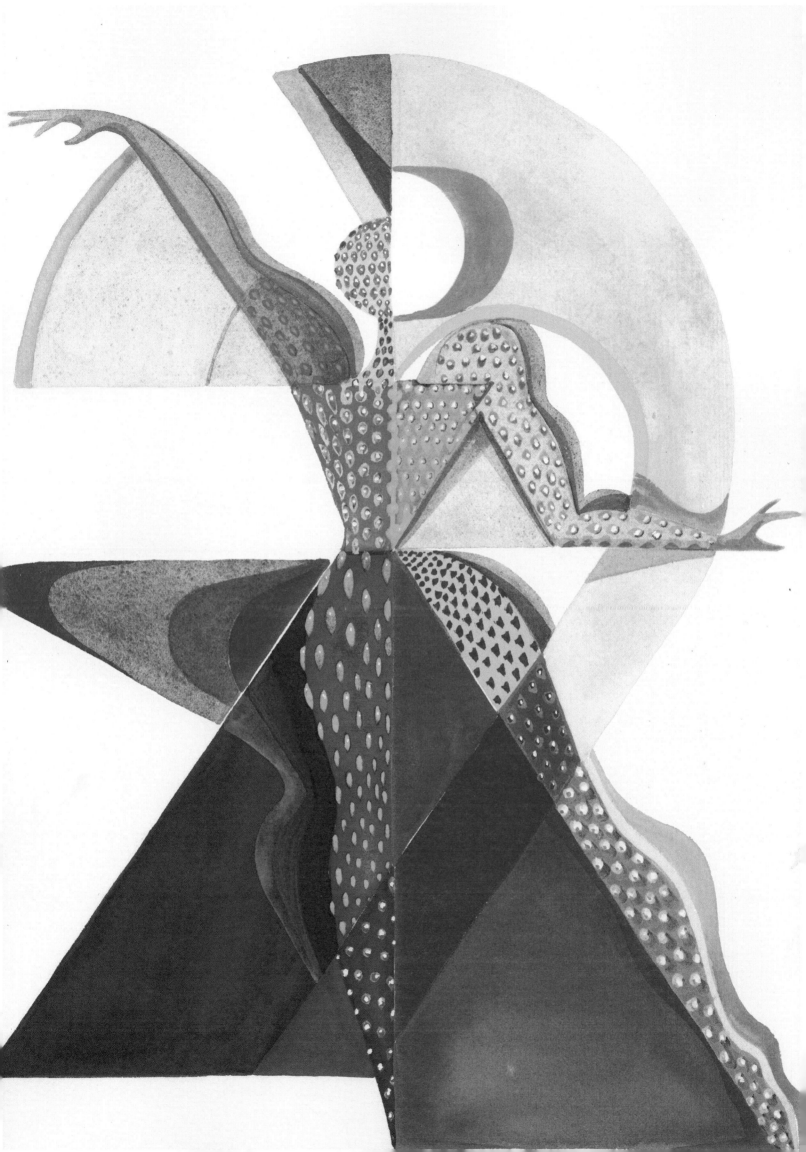

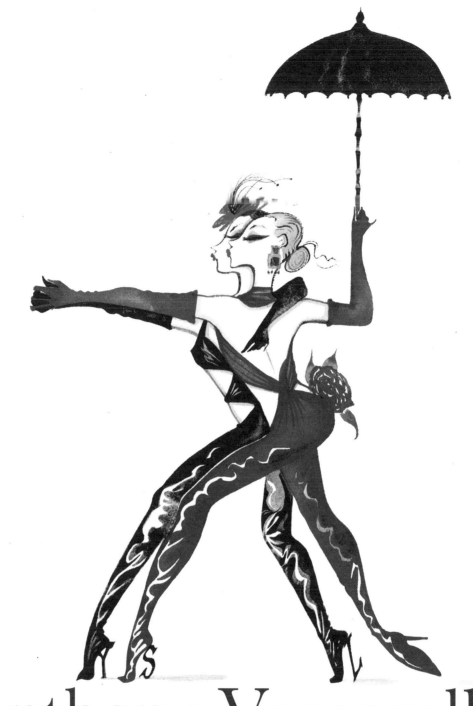

Anthony Vaccarello

(1982–) Belgian. Designer, creative director at Saint Laurent and founder of eponymous fashion label.

"As one of Monsieur Saint Laurent's successors, I love his subversive approach to clothes, the dark romanticism with a hint of perversity."

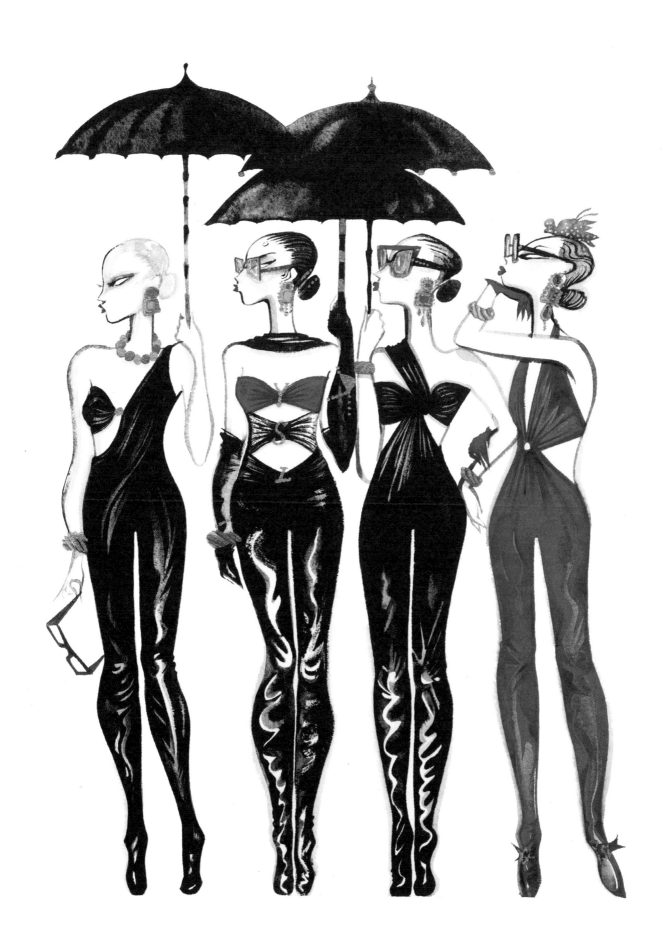

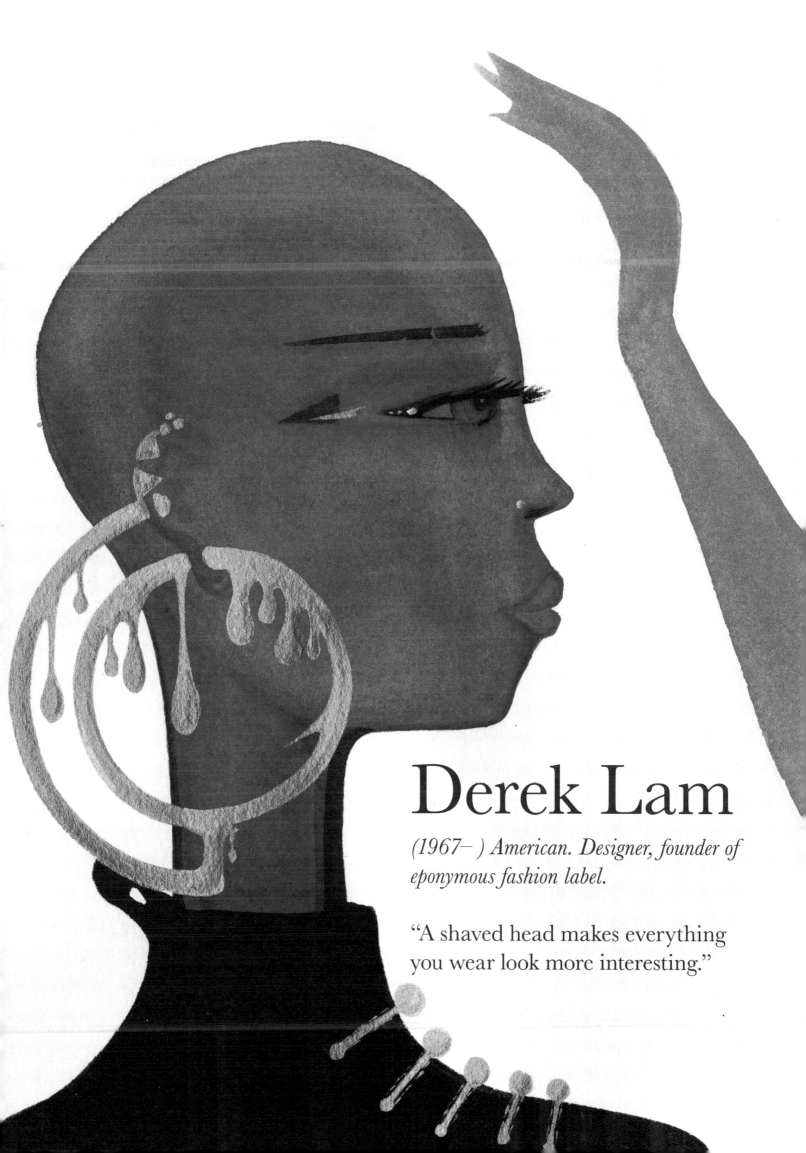

Derek Lam

(1967–) American. Designer, founder of eponymous fashion label.

"A shaved head makes everything you wear look more interesting."

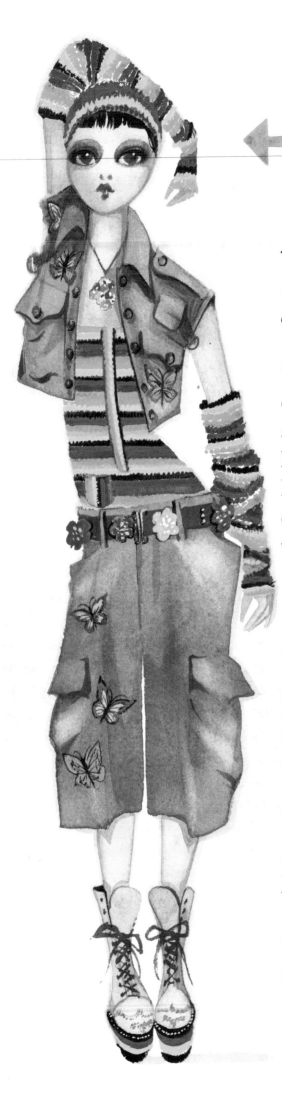

Anna Sui

(1964–) American. Designer, founder of eponymous fashion label.

"At the point when I wanted to become a designer, I didn't think about 'Oh, but I'm a woman,' just like I didn't think about, like, well, 'I'm Chinese,' or that 'I'm from Michigan,' or that those things were obstacles. I just had this idea that this is what I had to do."

LaVetta of Beverly Hills

(1940–) American. Designer, writer, founder of LaVetta of Beverly Hills.

"Finally, we are judged by our talent, and not by the color of our skin. AT LAST!"

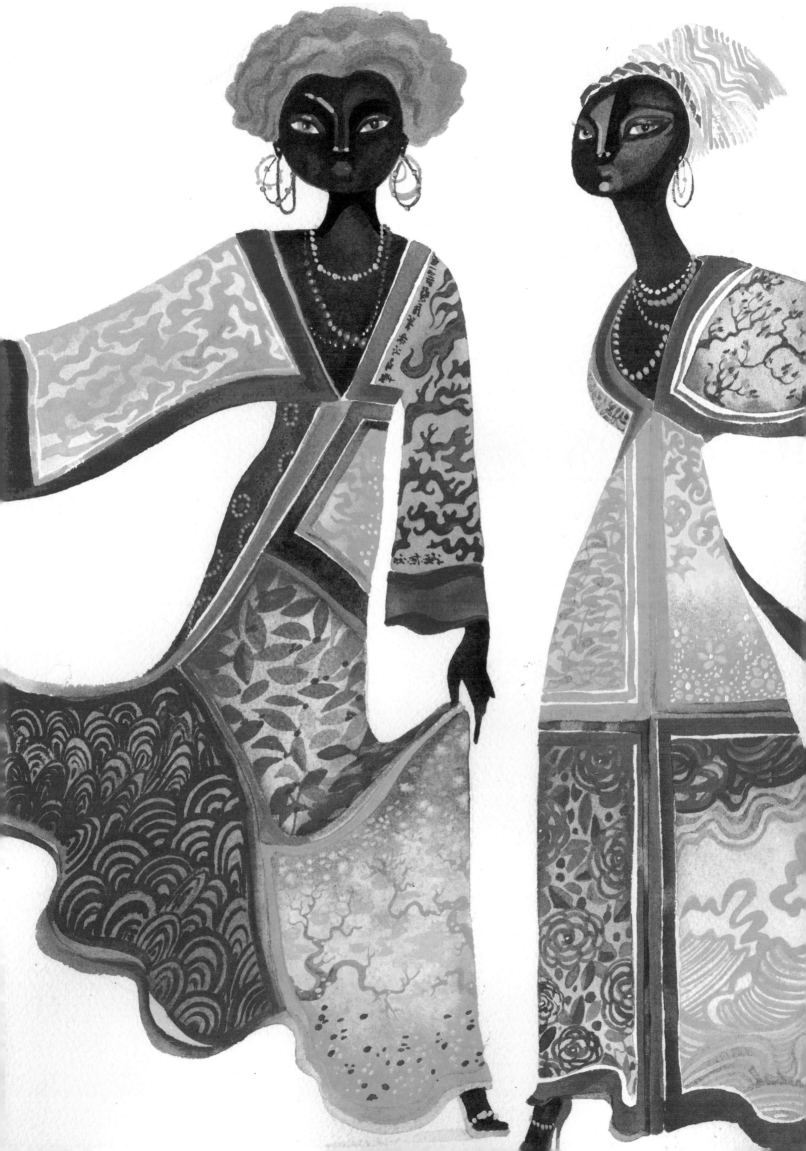

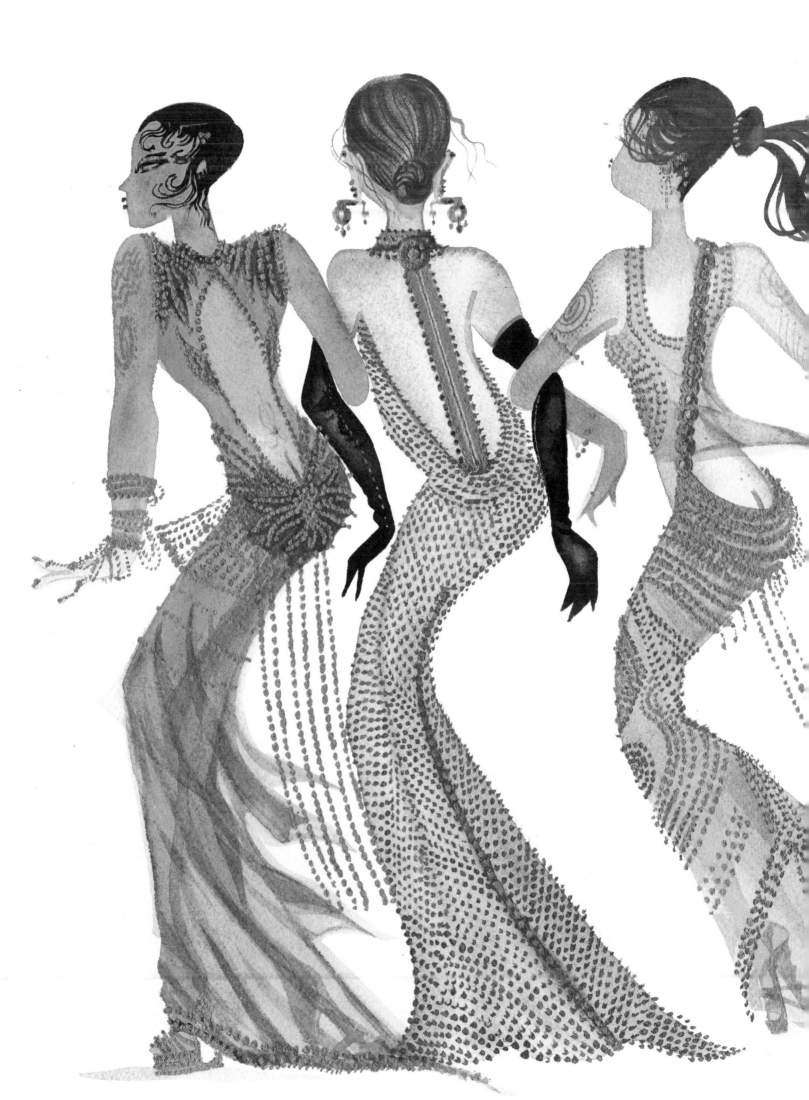

Riccardo Tisci

(1974–) Italian. Designer, creative director emeritus for Givenchy womenswear and chief creative officer of Burberry.

"I work a lot on the back. I love the back of clothes. I love even T-shirts printed on the back. I ask why one would want to show only the front?"

Kerby Jean-Raymond

(1986–) Haitian-American. Designer, founder of Pyer Moss fashion label.

"The ultimate sign of trust is a subject lending you their body as a canvas. Making good fashion is a sign of respect for that trust. It's important we not make it just beautiful, but also an extension of what we think the wearer wants to say without their words."

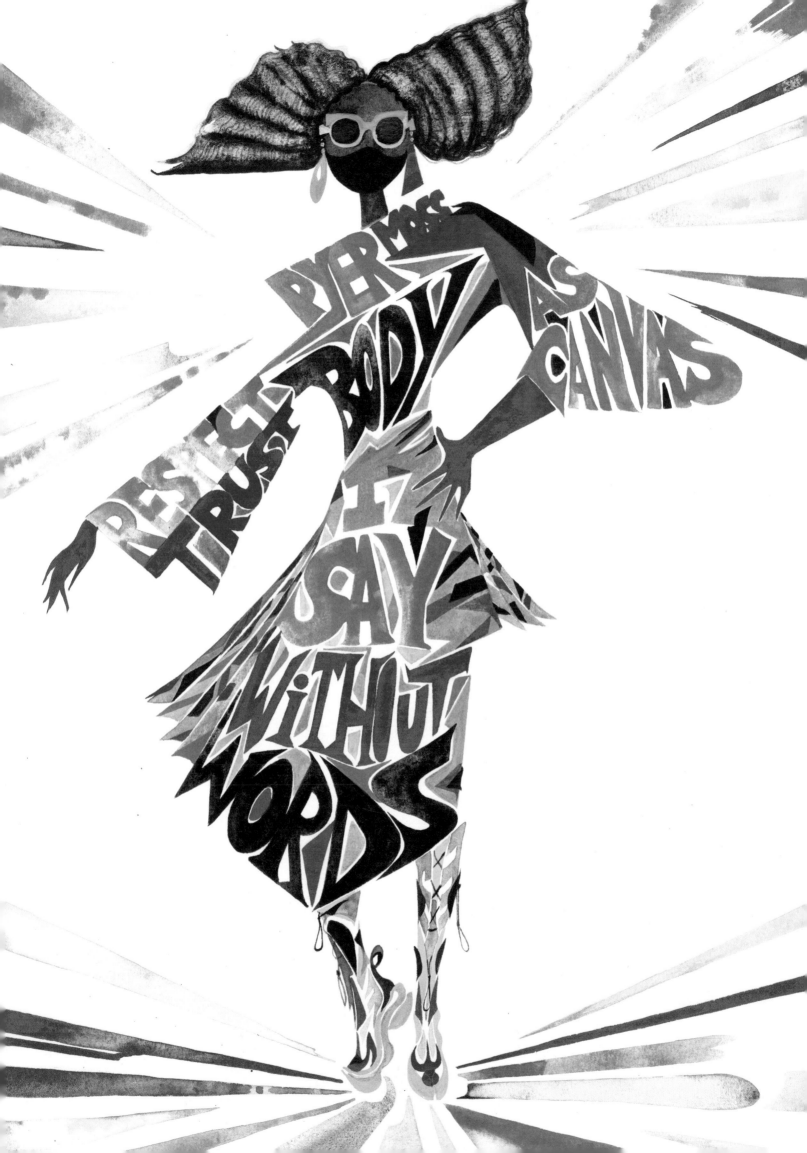

Jonathan Anderson

(1984–) British. Designer, founder of JW Anderson, creative director of Loewe.

"As a body of people who work in fashion, we need to start thinking forward. It cannot just go back to how it was. And if it does—then it will collapse."

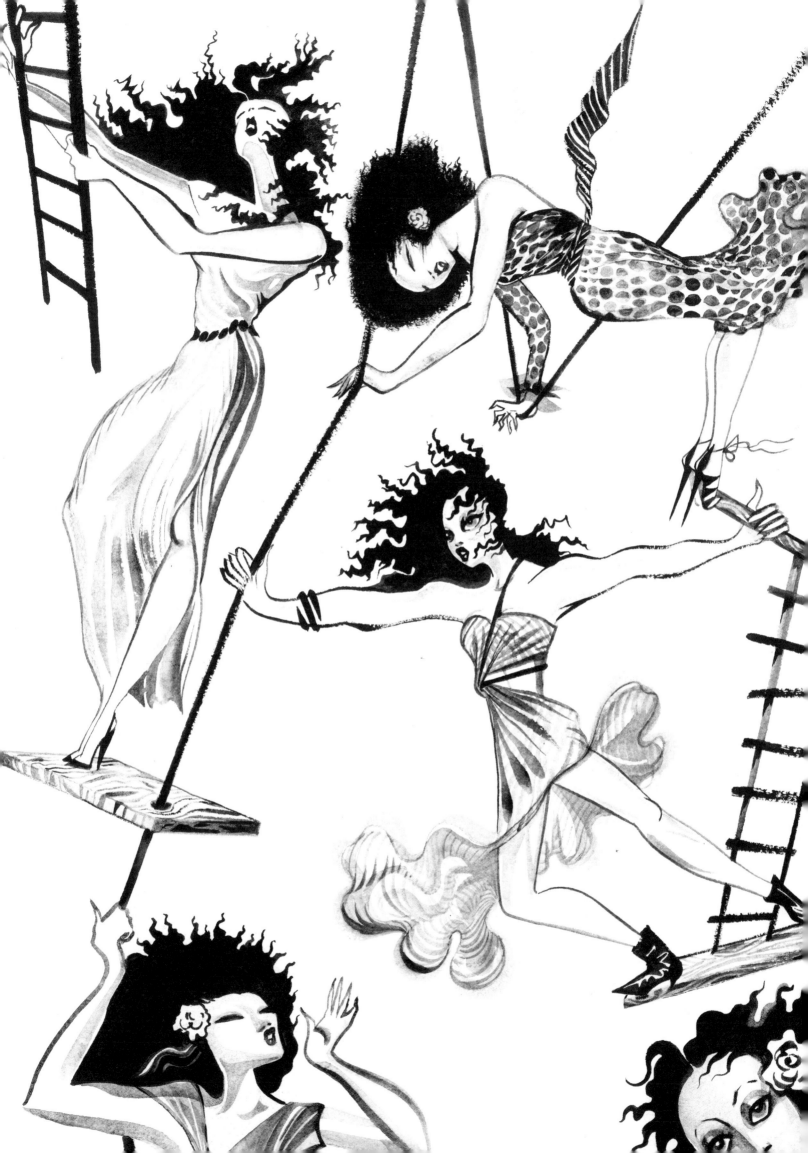

Jean-Charles de Castelbajac

(1949–) French. Designer of apparel, interiors, and furniture.

"Fashion is dead! Vive le style! Sustainability, crossover, and ethnicity will inspire minds to design the future. After the virus comes responsibility. After the flood comes the rainbow."

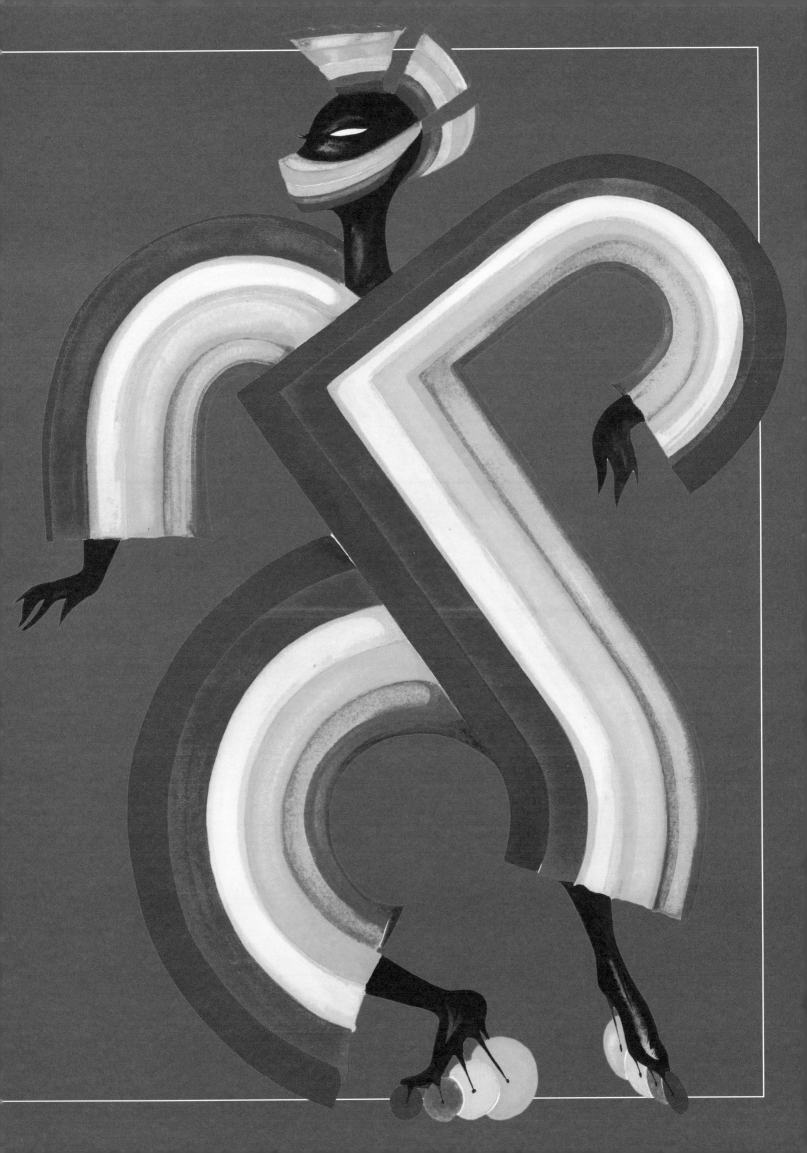

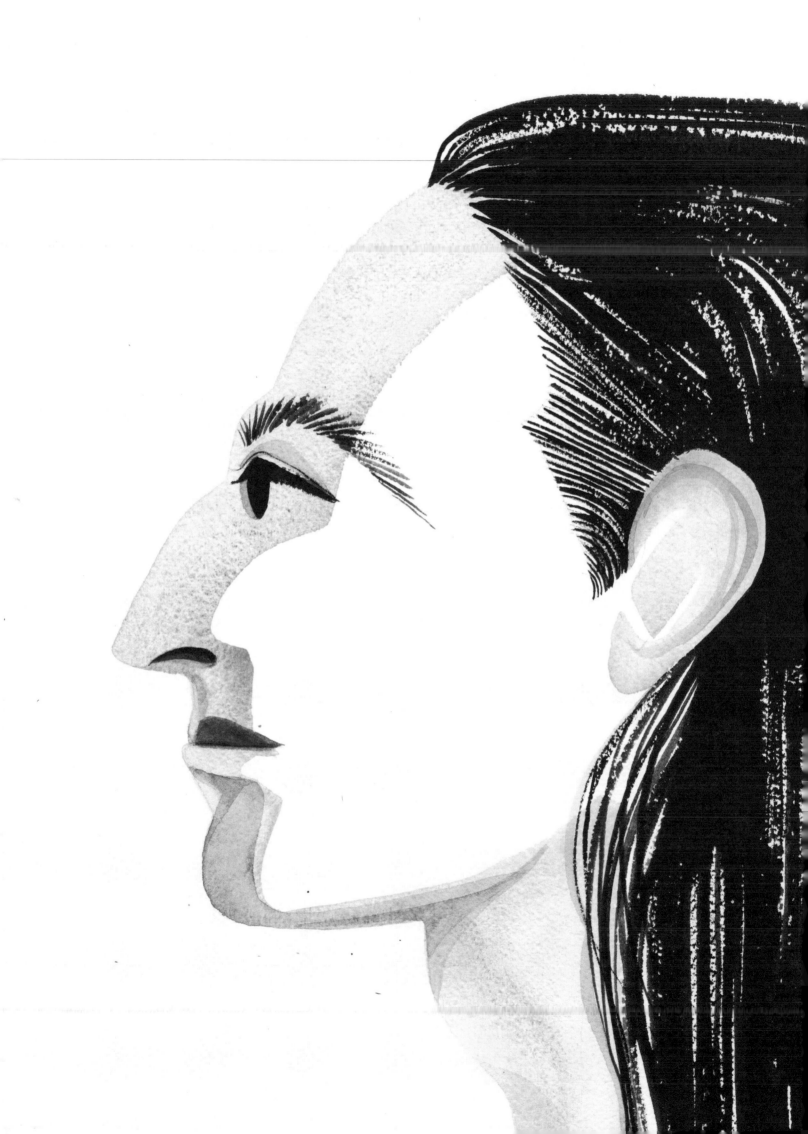

AFTERWORD

The quotes in this book are pointed passages from the language of fashion. Distilled messages from the men and women who created, and are creating, the clothes and accessories that express their era, their moment in time.

Be-Spoke is an encyclopedia of thoughts, afterthoughts, and never-before-thoughts from designers past and present—a chronicle of designer ideas, designer complaints. Opining and whining from those who dress us. Apologias for Generation X. Hallelujahs for Gen Z.

Our thoughts differ on how we met, but Marylou and I agree on where we met: Paris. What I remember most about that initial meeting was Marylou's twinkle. The twinkle of an eye can seem like a trite cliché, but her twinkle is real. It's a combination of warmth, kindness, and enthusiastic curiosity that isn't rushed or hyperbolic, but gentle and considered.

I don't know if it was my sense of inevitability or Marylou's sense of quiet satisfaction, but I do know that a bond was established that would last thirty years. And counting. Marylou was always there, front row, except for once when Lenny Kravitz's impromptu attendance caused a misguided press service person to bump her to the second row. That person was disengaged the next morning.

Lenny Kravitz would add to his reputation with his last-minute cancellation of an award presentation to me at a Fashion Group International ceremony in New York. I really didn't know Kravitz very well and was a bit embarrassed/confused by the necessity of having to have a celebrity presenter. When mine, Kravitz, didn't show up, Marylou stepped in to present the award and it felt right and true to receive an award from a serious fashion sage who had been there not only at my beginning but at the beginnings of so many others.

In addition to intelligent journalistic coverage from her, I have received innumerable notes of approval and congratulations from a discerning eye that I know has seen it all. To receive praise from someone who has truly done her homework and devoted a lifetime to the pursuit of excellence in the aesthetic arena that is the fashion world is a very rare thing—and even more rare when delivered with a twinkle.

So what is the moral of this story?

I see it as proof that we were put on this earth to communicate and to get to know each other.

Basically, fashion is about communication. Marylou and I are fashion communicators.

Rick Owens

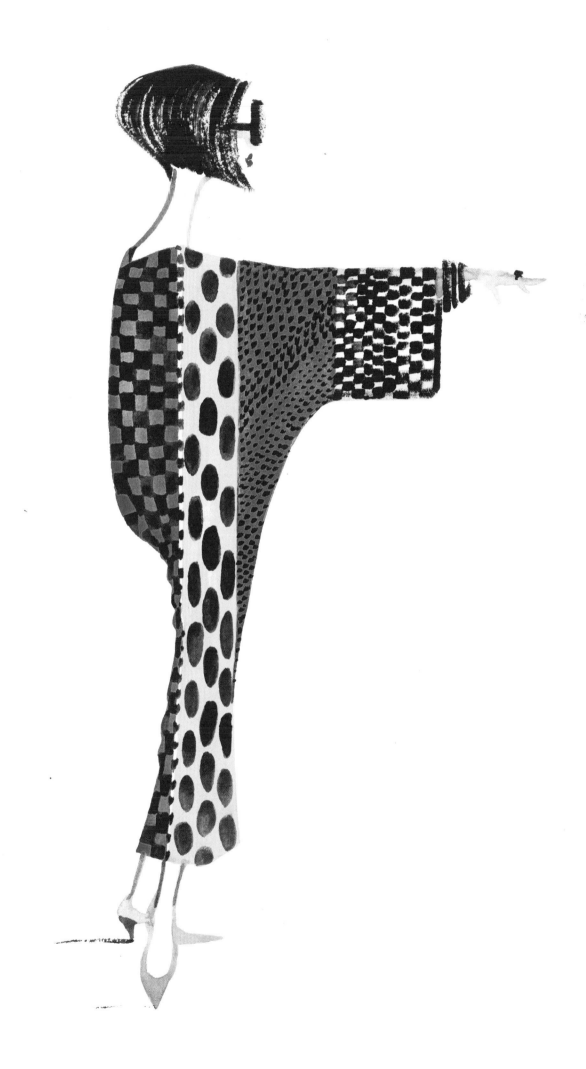

First published in the United States of America in 2023 by
Rizzoli International Publications, Inc.
300 Park Avenue South
New York, NY 10010
www.rizzoliusa.com

Copyright © 2023 Marylou Luther
Foreword: Stan Herman
Afterword: Rick Owens
Illustrations: Ruben Toledo
Art Direction and Design: Marc Balet
Graphic Assistant: Asja Gleeson
Research Assistant: Nicholas Imparato

Publisher: Charles Miers
Associate Publisher: Anthony Petrillose
Editor: Gisela Aguilar
Production Manager: Alyn Evans
Managing Editor: Lynn Scrabis
Design Coordinator: Olivia Russin

Printed in China

2023 2024 2025 2026 2027 / 10 9 8 7 6 5 4 3 2 1

ISBN: 978-0-8478-7202-2
Library of Congress Control Number: 2022932323

Visit us online:
Facebook.com/RizzoliNewYork
Twitter: @Rizzoli_Books
Instagram.com/RizzoliBooks
Pinterest.com/RizzoliBooks
Youtube.com/user/RizzoliNY
Issuu.com/Rizzoli

Marylou Luther is the editor and founder of the *International Fashion Syndicate* and creative director emeritus of The Fashion Group International. In 1991, she won the Council of Fashion Designers of America Eugenia Sheppard award for fashion journalism. In 2004, she received the Marylou Luther Award for fashion journalism at the Ace Awards. She served for sixteen years as the fashion editor of the *Los Angeles Times*, and before that fashion editor of the *Chicago Tribune* and *Des Moines Register*. She also edited "McCall's Fashionews."

Luther's essays have appeared in *The Rudi Gernreich Book*, *Thierry Mugler: Fashion Fetish Fantasy*, *The Color of Fashion*, *Todd Oldham: Without Boundaries*, and *Yeohlee: Work*. A book with Geoffrey Beene, titled *Beene by Beene*, was published in September 2005.

In 2008, France's Ministère de la Culture et des Communications awarded her the Chevalier de L'Ordre des Arts et des Lettres award. A graduate of the University of Nebraska, Luther received the Alumni Achievement award, and was a member of Phi Beta Kappa, Kappa Tau Alpha, Theta Sigma Phi and Gamma Phi Beta. She is the widow of Arthur Imparato and mother of two sons, Walter, a photojournalist for CNN, and Andrew, executive director of the Association of University Centers on Disabilities, the stepmother of Arthur Imparato Jr., and grandmother of Gareth, Nicholas, and Luna Imparato.

Cuban-born **Ruben Toledo** is an artist whose work has appeared in *Vogue*, *Harper's Bazaar*, *Elle*, the *New York Times*, and many other publications throughout his thirty-five years working in fashion. Together with his late wife Isabel Toledo, their combined work has been the subject of various museum exhibitions worldwide. He has known Marylou Luther for his entire professional working life and can attest to her "national living treasure" status.

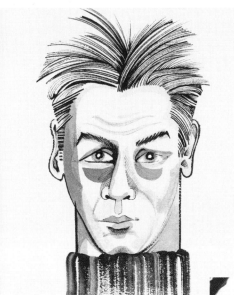

Calvin Klein

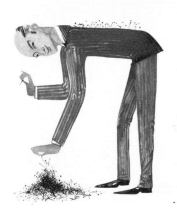

Oscar de la Renta

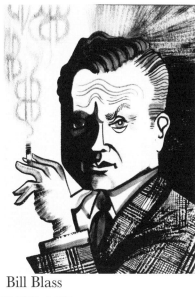

Bill Blass

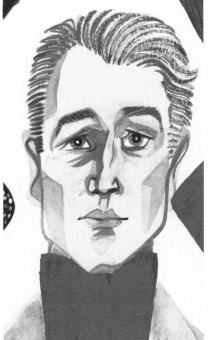

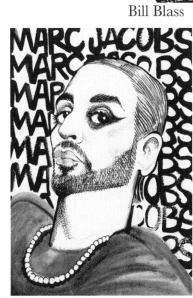

Stephen Burrows

Halston Frowick

Marc Jacobs

Virgil Abloh

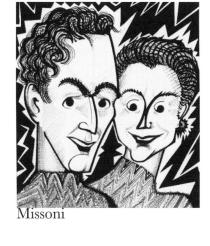

Missoni

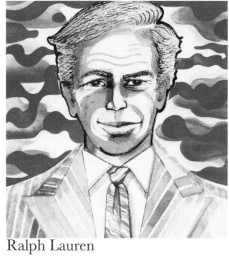

Christian Francis Roth

Way Zen

Ralph Lauren

Thierry Mugler

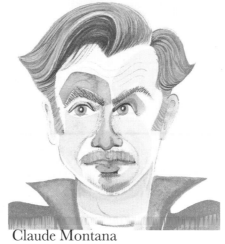
Claude Montana

Nicolas Ghesquière

Rei Kawakubo

Yohji Yamamoto

Hedi Slimane

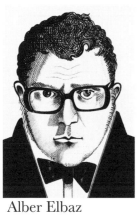
Alber Elbaz

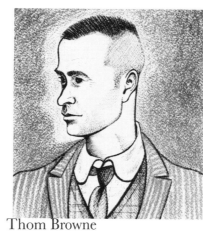
Thom Browne

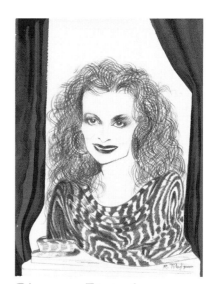
Diane von Fürstenberg

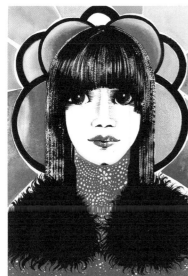
Anna Sui

LaVetta of Beverly Hills

Ricardo Tisci